go fug yourself

PRESENTS

THE FUG

HEATHER COCKS AND

AWARDS

SIMON SPOTLIGHT ENTERTAINMENT

New York London Toronto Sydney

JESSICA MORGAN

SIMON SPOTLIGHT ENTERTAINMENT
An imprint of Simon & Schuster
1230 Avenue of the Americas, New York, New York 10020
Text copyright © 2008 by Heather Cocks and Jessica Morgan
Illustrations copyright © 2008 by Jane Archer/www.janearcherillustration.com
Red carpet photograph copyright © Tim Pannell/Corbis
Designed by Jane Archer
Manufactured in the United States of America
First Edition
2 4 6 8 10 9 7 5 3 1
Library of Congress Cataloging-in-Publication Data
Cocks, Heather.
Go fug yourself : the fug awards / by Heather Cocks and
Jessica Morgan.–1st ed.
p. cm.
ISBN-13: 978-1-4169-3804-0
ISBN-10: 1-4169-3804-4
1. Entertainers–United States–Anecdotes. 2. Costume–Humor.
I. Morgan, Jessica, 1975– II. Title.
PN2285.C556 2008
818'.607—dc22
2007026517

Photo credits appear on pages 261–268.

Dedicated to Intern George:

You are our light, our inspiration, our everything.
As Bryan Adams so brilliantly pointed out,
everything we do, we do it for you.
Also, please restock the bar when you come
to work tomorrow. We're out of gin.

contents

Welcome to The Fug Awards 9

Girl, PLEASE 11
Most Inexplicable Style Icon

The Sag Award 31
Most Egregious Misuse of the Privilege
of Having Breasts

The Carefrontations 43
Most Likely to Require a Tough-Love
Fashion Intervention

Put It Away 71
Most Underclad and Overexposed

The Peldon Prize 89
Most Stunning Achievement in Sibling Fuggery

The Errstyle 109
Most Vexing Coiffure Catastrophes

The Tanorexia Award ⭐ 125
Orange You Sorry You Paid for That?

The Dr. Nooooo! ⭐ 141
Most Tragic Surgical Choices

The Pits and the Pendulum ⭐ 159
Most Maddeningly Inconsistent Dresser

The Cher ⭐ 185

The Cher-Alike ⭐ 205

The Fug of All Fugs ⭐ 227
Fugliest Fughound That Ever Fugged

The Afterparties ⭐ 255
Because All Good (and Bad) Awards Shows
Must Come to a Dizzy End

Acknowledgments ⭐ 259

Welcome to THE FUG AWARDS

t's happened to everyone: You're sitting at home, leafing through a gossip magazine, and you come across a photo of a beautiful young style icon wearing something that looks like it came from the Salvation Army's Dumpster. And you think, "Ugh. What's *wrong* with these people? Why, back in *my* day, celebrities didn't dress like they'd rolled out of the gutter before running to their late shift at Taco Bell. They walked uphill both ways on one leg, over shards of glass and through blizzards, just to pick up a custom-made gown for the grocery store. How I *long* for those glamorous days!"

At Go Fug Yourself HQ, we shoot barbed arrows at these poorly dressed millionaires almost every day of the year. We define "fug" as a contraction of "fantastically ugly," because our parents raised very nice young ladies, even if we do have a closet full of cranky pants. Mere ugliness is a condition above which someone can rise, but fugliness is brought upon oneself. Some people attribute the birth of the word "fug" to the writings of Norman Mailer, while others are pretty sure it was coined at one of their college keggers. But we're here to settle that debate once and for all: A young lady wrote us to say that her mother invented the word in Ohio in 1951, so there you have it.

The actual *concept* of fug has been around since ancient times. We're pretty sure that at least a few ancient Egyptian hieroglyphs mock King Tut for swanning around in those sassy little miniskirts. And don't think for one second that the Native Americans who bumped into the Pilgrims at Plymouth Rock weren't laughing amongst themselves at those gigantic buckled hats and shoes, not to mention the foppish white kneesocks. (We can see it now: "Good luck

finding any club soda to get that out," Pocahontas would snicker to her girlfriends as John Smith tried to brush turkey blood off his shins.)

Today the world is in the throes of a full-on fug epidemic. This is the fugliest era of all time. The seventies had frightening moments, the eighties are better left boxed up in the closet with our yearbooks, and let's not even *talk* about those stirrup pants we wore in 1991. Those were all mistakes somebody had to make so that we'd know not to do it again. And yet, here we are, watching celebrities drag all those awful old fashions back to the fore.

Why? In part, because the explosion of the world's fascination with celebrity culture can yield poor judgments from people suddenly thrust into the public eye. Being deemed a fashion inspiration or icon is critical to fame in today's world, so stars jockey to look the most striking, funky, or even retro-chic on the red carpet, whether the outfit is sane or not. It's a battle of supremacy that's brought on everything from formal shorts to arm warmers, and we viewers are the helpless victims.

Some of these achievements in fuggery are so enormous, so brilliant, and so utterly replete with misguided vanity that they are the stuff of legend. It would be wrong to let these feats fade into the past without commendation. To be the best of the worst is a unique achievement that takes commitment, effort, and a complete lack of any reflective surfaces in the immediate vicinity.

If every other branch of the entertainment industry has lavish ceremonies for the best and brightest, then why can't we honor the equally stunning accomplishments of the worst and dimmest? Can't somebody give those poor hot messes a little love and recognition?

We say yes. In the years since we started Go Fug Yourself, we've railed against the figure-swallowing tent dresses, the unwashed hair, and the Ugg boots with cocktail dresses. We've witnessed terrible mistakes, triumphant comebacks, and tragic backslides, so we're well qualified to hand out the love.

Admittedly, it's tough love. Sometimes it's merely tough *like*. Or just tough. But admit it: Aren't you just dying to know who in Hollywood has the most debilitating case of tanorexia? Or whose plastic surgery has gone the most terrifyingly awry? When you're lying awake at night, aren't your thoughts focused entirely on wondering which celebrity most needs to talk to her therapist about her delusions of Cher-dom?

We have answers to all those questions, as decided by our very focused, very biased, very *efficient* academy of two. "But Heather and Jessica, you judgmental cows," you might ask, "how are you picking the winners?"

For us, the only requirements for nomination for a Fug Award are: (a) you must be at least vaguely recognizable as a celebrity working in the entertainment sector; (b) your moment of fugitude occurred within the 2000s; and (c) it either amused or terrified us, preferably both. Anything else, we don't care about. Your stylist actually dressed you? You lost sight in one eye that day? You were doing research for a role as a woman who very specifically has bad taste? We don't care.

This tome is a snapshot of an era—a complicated time in which we've been asked as a people to accept certain things we simply don't want to swallow. It can't possibly cover everything, but if somebody unearths it from under a pile of rubble forty years from now, they'll be able to say with certainty, "Holy God, those implants were a mess." And, really, that's all a couple of snarky bitches like us could ever hope to achieve.

★ 1

Girl, PLEASE

Most

Inexplicable

Style Icon

The It Girl phenomenon is probably as old as celebrity itself. We're too lazy to do any actual research about this, but don't you think Cleopatra had people emulating her headdresses, or whatever she wore around the pyramids? That sounds about right to us, and if we know our readers, you are also too lazy to check. For that, we salute you.

t Girls take all forms, kind of like the way Gozer the Destructor took the form of the Stay-Puft Marshmallow Man in *Ghostbusters*. Some of them sing, some of them act, some of them model, some of them are just "muses" to other people. No matter what they do to pay the rent, they're held up to us as women we ought to aspire to be. And you know what? Sometimes we do. Sometimes these style icons are, in fact, actually superstylish. But then other times you look at them and think, "Really? THAT girl?" You know, just because someone is on a popular TV show and has good hair doesn't mean she can dress herself. And when that happens—when someone has been mistakenly crowned That Girl with the Fantastic Sense of Style!—it is our duty to speak out. And also to shame that misguided style icon into shaping up by giving her this award, which sports its very own pair of Uggs. Which, unfortunately, we're pretty sure the winner would love to borrow.

Our nominees are: a starlet so reviled by the audience of the show that made her famous that her character's death was cheered across the land, an actress whose most famous roles involve either oral sex or polygamy, an actress whose most famous role has been in the tabloids, a stylist, and Gwen Stefani.

Mischa Barton

The O.C.

The O.C. introduced several items of tremendous cultural significance to the world: Peter Gallagher's eyebrows, the band Phantom Planet, and the artful use of the word "bitch" to close a sentence, to name merely three . . . bitch. But for our purposes, the most pervasive by-product of the short-lived but blistering popularity of the show was the media attention paid to Mischa Barton. As the show's adolescent leading lady, Marissa Cooper, Barton slouched her way through three seasons of typical teen angst. She got kidnapped and held at gunpoint by a preppy psycho she met in therapy (at a really nice hotel, but still); turned into a lesbian, got bored of it, and turned back; almost OD'd in Tijuana; had a traumatic on-again, off-again relationship with a sensitive boy from (ew!) Chino; suffered myriad substance abuse problems; found out that her mom was sleeping with her ex-boyfriend; and was forced, briefly, to live in a trailer; all before she was killed when her stalker (not the preppy psycho but a totally *different* stalker) ran her car off the road. Barton's reaction to these indignities was pretty much the same each time—wooden, with good hair. The fact that many groups of *O.C.*-watchers hosted gleeful viewing parties the night her character was killed off illustrates that maybe Marissa Cooper didn't turn the world on with her smile the way she was meant to.

While M. B. as M. C. left us cold, Barton herself has been a big hit with Those Who Decide Which Starlet Is Superhot and Ultra-Fashionable. There are good reasons for this: She is undeniably pretty, and when she gets it right, she looks amazing. But when she gets it wrong—and that's more often than not—OH MY GOD, IT'S SO WRONG. Which is all the more frustrating because she's got so much going for her.

Instead of taking what the rest of us would praise Jesus to wake up with and WORKING IT, Barton usually drapes it in something that would be considered "dowdy" by cloistered Carmelite nuns, "old" by that mummified iceman they excavated from the Tyrolean Alps, and "ugly" by the rest of the people in this book.

So you tell us: Is this girl a fashion icon? Or does she need to get her eyes examined?

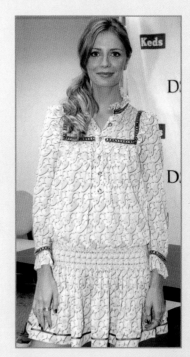

COME ON: Mischa's wearing a child's dress that appears to be made from the same curtains Maria bastardized for Liesl, Friedrich, Louisa, Kurt, Brigitta, Marta, and Gretl von Trapp. And while we love *The Sound of Music*, we

don't run around dressed like novices. Well, not in public.

Mischa screws it up when she goes out for formal occasions as well.

From the neck up, she's charming. From the neck down, she appears to be wearing a formal Hefty bag. Chic!

Speaking of bags, don't tell us that we're all supposed to run out and buy ourselves one of these:

No offense to all the bag ladies out there who are rocking this look right now, but we're pretty sure this is what you end up wearing when you have an actual psychotic break.

If you're not blind yet, this ought to do it.

Or this:

Even SHE looks totally bummed out here—and who wouldn't be, schlumping around in shapeless sacks, no matter how shiny? Which begs the question: Why should we want to emulate someone who looks so unenthused to begin with?

Sienna Miller

Factory Girl, Casanova, Nannygate 2005

Remember those traumatic times in 2005 when every store was peddling flowing skirts, blousy tunic tops, thin camisoles, and all manner of other floaty clothes that only look good on the willowy and model-svelte? And this boho look was proliferating and propagating with more terrible efficiency than K-Fed's bionic swimmers? At which point you became horribly depressed and convinced you'd never again find a single cute shirt or skirt that didn't make you look ten pounds heavier, three inches squatter, two inches saggier, and moderately off your rocker?

We were right there with you. Those days of hopelessness are burned onto our brains, alongside the fateful moment when we realized our childhood dreams of marrying George Michael weren't going to work out as we'd planned. But if you'd care to engage in a little finger-pointing, there's a pretty traceable source to all this agony: a starlet whose off-the-wall and seemingly careless personal style mysteriously captivated the imaginations of all the wrong people through some sort of black magic we still don't understand. That starlet is Sienna Miller.

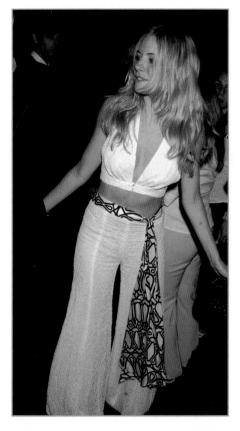

Examine, if you will, the actress out in the wild, cruising through a party in white cotton-eyelet genie pants, a matching "shirt," and a waistkerchief. This is the *perfect* look to copy for the brass-lamp fetishist in your life who lives to look like he/she just crawled out of one; indeed, Sienna looks like she's

staggering through the room in search of a good rub herself. She's just lucky the night did not end in tragedy with her hip scarf getting caught in a space heater.

Sienna also aided and abetted the resurgence of leggings—one of the ghastliest fashion crimes of the aughts.

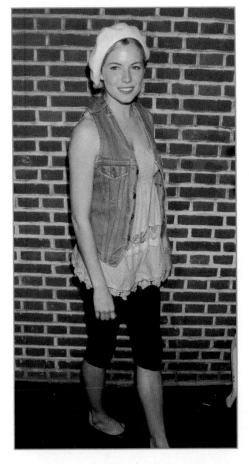

Unbelievably, she still earned consistent praise for her unerring eye, despite showing up in public in haphazard collections like this denim vest, dingy blouse, and beret—a hodgepodge of items suggesting that she closed her eyes, spun around ten times, then grabbed clothes at random and dressed while dizzy. However, we *would* like to congratulate Sienna on her stunning accuracy in replicating our Goodwill pile from 1994.

Who, exactly, decided to exalt this girl for her taste? And why did Hollywood's starlets trip all over themselves to copy it? Is it just because they were hammered? We get that Sienna is young and pretty, and she did score the upset of the decade on the British social scene by coming in as a virtual unknown, an unseeded (get your minds out of the gutter!) amateur, and toppling Sadie Frost's reign as the queen of Jude Law's realm. But what we can't fathom is why that translated into tabloids and newspapers tracking her every fashion move with slavish devotion.

In fact, so perplexing is this global embrace of her jumbled choices that we actually started suspecting Sienna was playing a practical joke on the world. Even before she told *Entertainment Weekly* in November 2006 that she was weary of being seen as a clotheshorse first and an actress second (well, third, technically, as she tends to rank as "Jude's former bit of stuff" before anyone recalls that she has a career of her own), we developed the theory that Sienna had begun throwing

on any inane thing her mischievous mind could think of, just to see whether anyone copied her.

Like, say, a harness.

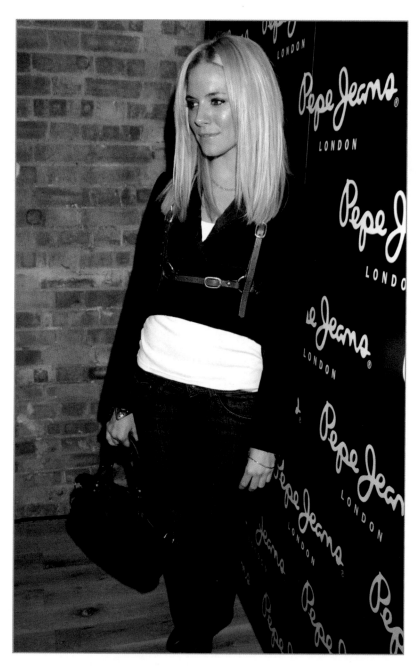

Or a black sheath fastened across her boobs with nothing but a giant belt (apparently, she has an obsession with strapping down her chest—is she afraid that, disgusted with how she clothes them, the ladies are plotting an escape?).

Yet people still think she's a genius. In fact, her countrywoman Keira Knightley *did* ape this look. She belted what looked like a child's bedsheet and wore it out as a summer minidress. It was traumatic. We're still not okay.

These photos are just the tip of the iceberg. Sienna has also been spied wrapped in what appeared to be a moldy tarp; a niptastic one-piece bathing suit under shorts, worn to a restaurant that on ordinary days almost certainly enforces rules about such things; and, unforgettably, jeans and a T-shirt accessorized with a bowler hat and sandals whose ankle straps she tied up *outside* the legs of her pants.

All of this is less iconic than idiotic, less aspirational than asinine.

And while we're here, quit your whining, Sienna. Given these atrocities, you're lucky people *do* shed that inexplicably positive light on your fashion sense, so stop complaining about how it overshadows your work. That's a champagne problem if we ever heard one.

Chloë Sevigny

Kids, The Brown Bunny, Big Love

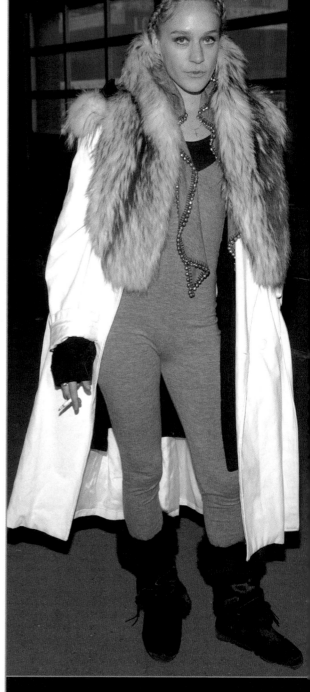

If this were a real awards ceremony, this would be about the fourth consecutive nomination in the Girl, PLEASE category for Chloë Sevigny, making her the Meryl Streep of The Fug Awards. You might contend that giving her this kind of attention only eggs her on, but, frankly, if she keeps being held up to us as an example of sterling style when she shows up to places wearing her grandma's housecoat and a skirt made out of an umbrella, we'll never be able to turn a blind eye. Unless her clothes are what finally blind it.

Like the rest of the women in this category, Chloë is lovely, and when she gets it right, she looks like a million bucks. And yet she gets as much positive feedback for wearing hip waders and a sequined bra as she does for wearing something gorgeous and flattering. She gets a pass for something that would be considered completely freakish on someone else, simply because she's already been crowned a style icon. In other words, if *she* does it, it must be okay. But forget everything you've ever read about how chic Chloë is—and there has been a *lot* to choose from in that vein—and ask yourself: Does any of this actually look good?

Because to us it looks like a girl in:

(a) a skintight cotton catsuit that is suitable only for the "before" picture in a Monistat ad;

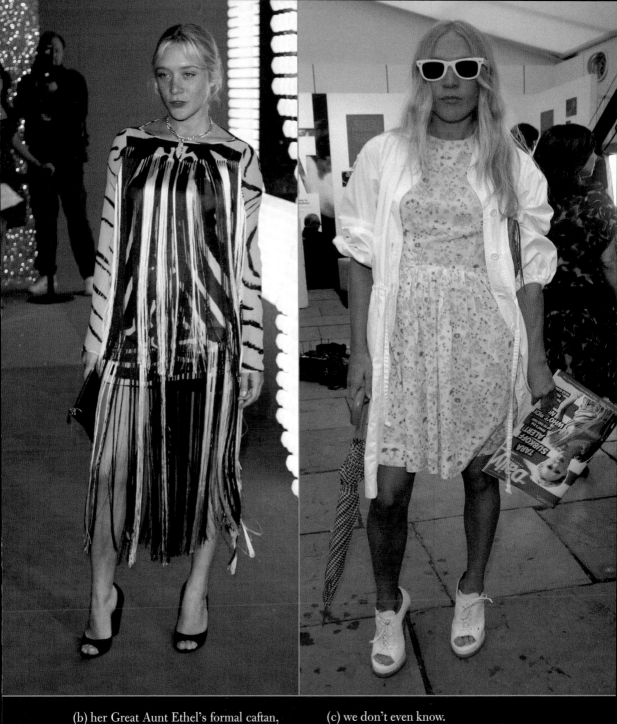

(b) her Great Aunt Ethel's formal caftan,
as styled by an angry falcon;

(c) we don't even know.

It has occurred to us that perhaps Chloë, too, is playing an elaborate, years-long trick on fashionistas and celeb-watchers alike, concocting ever-more-ridiculous getups merely to see how much she can get away with—sort of like "The Emperor's New Clothes," but with hot pants.

Can't you imagine her cackling as she pulled this one over on us?

"Oh, this is a good one! Pegged pants! With grandpa's boxy sweater! Oh, hahahaha! If they fall for this one—hahaha, oh, I can't go on! It hurts!"

Or this one:

"I'll just tell them it's an homage to *Grey Gardens*. Oh, I slay me!"

Well, Chloë, you might have some people snowed, but not us. We're on to you and your nefarious scheme to outfit the children of the world like goofy morons, all for your own amusement. If we have our way, you won't be known as Chloë Sevigny: Style Icon, but rather Chloë Sevigny: Smarmy Trickster. And that won't get you into *Vogue*, missy.

Gwen Stefani

Singer

Gwen Stefani's pseudo hip-hop vibe with that hint of old-school glamour gives her a lot of leeway to try to meld those two styles, and she attacks it with gusto. Sometimes she succeeds.

But let's be honest: A lot of what she wears just doesn't make sense. At all. That's why it chaps our hide like a frigid winter wind when article after article in the media proclaims her brilliance, as if she's incapable of a misstep even when one appears to be kicking us in the face. She's revered as if everything she does is so ahead of its time we don't even understand how awesome it is, as if every ensemble that dribbles from her closet is pure, unadulterated genius, and if you don't get it, that's your problem, and you'll be left to marinate in a rank puddle of your own stupidity while the rest of the world exalts her by wearing pirate shirts.

And hey, if that's all true, then fine. Buy us a raft (with two cup holders, please) and we'll paddle around Lake Myopia for the rest of our pathetic days. Because you know what? We don't see what's so brilliant about, say, a crown of fake flowers.

Also, nice legs and all, but unless Gwen knows something we don't about the future of synchronized swimming as our new national sport, we refuse to believe that her all-seeing fashion eye showed her a world in which we all frequent Cowboy Dan's Hobbyhorse every week to replenish our stock of plastic blossoms. So instead, this just comes off as merely deranged. Inexpensively deranged too, which *nobody* wants—if you're going to topple off your rocker, do it in fur stoles, turbans, and jewels that outsize your fists. Don't do it wearing a Little

White Chapel of True Love quickie-wedding bouquet on your head, handed to you by a woman dressed as Wayne Newton while a three-hundred-pound Elvis goes hunting for bobby pins.

We also fail to see the wisdom in footless tights. These photos on the right are from Gwen's dalliance with Harajuku-chic, based on that famous district in Japan where girls hang out dressed completely seriously as everything from hard-core punks to Little Bo Peep. The more outlandish the better; if you look crazy-eclectic, then you're too conservative. That aesthetic works in its own cultural context, but it looks forced and sad when Gwen adopts it in the West.

Gwen debuted her Harajuku wardrobe—and a posse of silent Japanese girls who followed her to every event—when she dropped her first solo record, and the only thing that stopped it was her pregnancy. Her combinations of clothing became increasingly bizarre: Here, the same pair of stark-white delicates went under shorts *and* with a tutu that matches the tuxedo that every geek in the class of 1974 wore to the prom.

These were neither the first nor the last times she brought out these little gems—whose merits we have yet to comprehend, particularly when paired with satiny hot pants, a heavy plaid blazer, and the leopard pumps over which they're pulled. Evidently, Gwen was in the throes of paranoia that somebody would pinch what look like very pricey Louboutins and decided that yanking down her tights and poking the heels through would be the best security measure. The tutu ensemble speaks for itself, and it says, "Hello, my name is Trixie, and welcome to the House of Copperfield Casino and Magicquarium. I greatly look forward to being sawed in half."

And yet, Gwen is so profoundly and universally lauded for what people see as her flawless taste that she has a fashion line, L.A.M.B. Granted, even Nicky Hilton has been able to start a clothing label, so apparently the only requirements for such are having a famous name and being able to scrawl it on a dotted line, but with Gwen, it's different. She's seen as a tastemaker, but based on outfits like the one pictured on the right, we find that increasingly sketchy.

Jamaica is a fine, fine country. We are especially fond of its rum exports; decidedly less so of leather tracksuits reminiscent of its national flag.

Also, we don't *want* to wear the same tired crimson lipstick with every outfit—especially not with a messy, hipster-sloppy quasi-suit that's so long you can't see a trace of shoes.

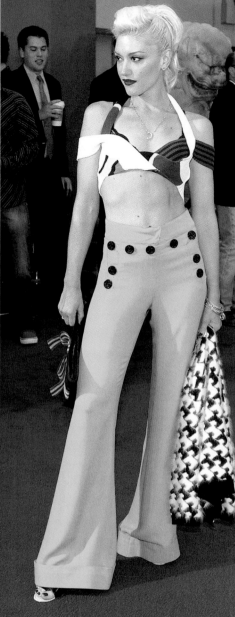

And for the love of all things trouser, we *do not* want to wear bell-bottoms with a waist so high it'll dilate your pupils. It's begging for attention in a quirky-for-quirky's-sake kind of way, and it's safe to say we're not enchanted.

Now, if you'll excuse us, we're off to build a house on stilts in our pond of ignorance.

Rachel Zoe

Celebrity stylist, poster child for the importance of good moisturizer

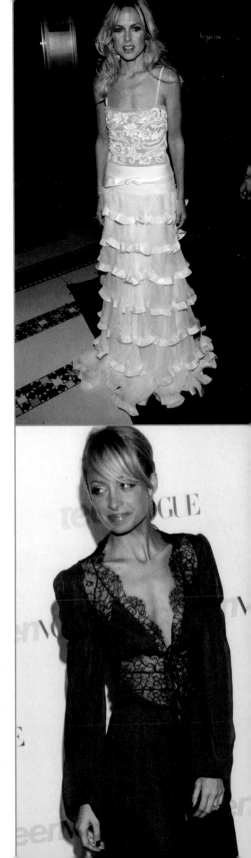

Rachel Zoe is not really a style icon herself, but given that she crafts her clients in her own image and then vigorously tries to convince the press and the world that *they* are style icons (as suggested by a 2006 *InStyle* interview, in which she claims everyone in Paris was emulating the look she helped create for Lindsay Lohan), we're pretty sure Rachel Zoe is a legend in her own mind. Which is quite sweet—after all, *someone* has to like her—but that's one leathery bubble we'd like very much to pop with our talons of intolerance.

First, let's consider the source of all this. Rachel seems so unnaturally thin that she often appears to be shriveling from within—even pounds of cake makeup can't fill the lines carved into her face by years of presumed overtanning and undereating. Not to mention whatever other extracurriculars she's rumored to partake in, the veracity of which we are not qualified to determine, although, to be fair, she swears she's clean.

Now take a look at Exhibit A—her highest-profile client, Nicole Richie. Granted, Nicole has since wised up and fired Rachel, but not before a prodigious weight loss that gobbled up more headline inches than she did solid food in the past two years. Here and in many photos like it, she shows off a cavernous sternum; shrinking mammaries; long, side-swept dirty-blond bangs; and that strained, starved neck with cords so taut you could strum them like a guitar. We also hate the goth nightie she's wearing here; bad choice, Rachel, unless Nicole was applying for a job as a cocktail waitress at a Wiccan bar.

Exhibit B is *Pirates of the Caribbean* actress Keira Knightley.

She looks bored, depressed, skinny, and, frankly, unhealthy in this gladia-trix disco queen gown. And although Knightley was never carrying all that much weight, her breakout role in *Bend It Like Beckham* as well as her scenes in *Love, Actually* show a girl who's naturally slender without being grossly bony. But here, she's sunk into the latter category, and, surprise, surprise, another Rachel Zoe client frustratedly found herself battling countless tabloid accusations of anorexia.

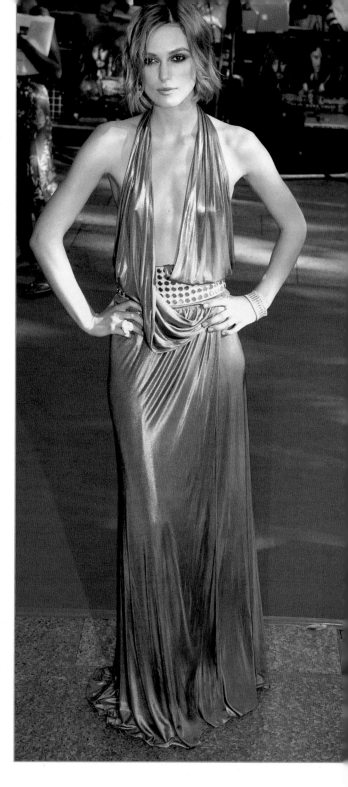

Exhibit C: Lindsay Lohan. Not only are we getting an unauthorized peek at the profile of Lindsay's right breast, but we're also privy to a view of every single muscle in her back because there's not an ounce of extra flesh on it. Prior to her association with Rachel (which included a Rachel-esque blond phase that still comes and goes), Lohan was actually rather inspiring in how lovely and normal-shaped she was. Then she hopped on the Zoe Train and immediately spent a year fighting off rumors of drug use (that now seem to have been true) and—you know what's coming here—eating disorders.

These abrupt body-fat makeovers often over-shadow the clothes Rachel chooses for her clients, which, frankly, aren't always that bad. And for the record, we're not saying any of these girls actually *have* eating disorders; we have no way of knowing, and it's not our place to put such a serious label on somebody. We just happen to have noticed that they've all lost weight—these are some solid, high-profile examples of girls becoming too skinny for their own good. The common denominator is Rachel Zoe, and we're pretty sure three's a pattern.

We also think Zoe needs to be strapped to a table, moisturized, and force-fed some fried chicken. Her face looks as broken-in as three-year-old cowboy boots. And if that's part of the makeover plan, we're stunned more of her clients haven't run screaming.

AND THE BRONZED
UGGS GO TO . . .

Cherish them, **CHLOË SEVIGNY,** as you are the original
Inexplicable Style Icon, and still the best. Sienna Miller put
on a strong showing, but in the final review, she remains just a
weak imitation. Get back to us when you've bravely gone out
with an Art Garfunkel–style afro, Miller, and then we'll talk.

The Sag Award

Most

Egregious

Misuse of

the Privilege

of Having Breasts

We've seen it so many times that it's rivaling "The Erotic Awakening of Adam and Eve" as the oldest story in the book: starlet bursts onto scene; starlet finagles her way into the tabloids; starlet decides she is invincible and that bras are no longer necessary because her fame alone will defy gravity and prop up her lady-orbs until the end of time—or the end of her implant-free days, whichever comes first.

his philosophy is tragically wrong. So too is the idea that more is more when it comes to exposing the twin mysteries of the female torso, and the thought that shoving them up sky-high is an appropriate tactical countermeasure to fight the Dreaded Sag. We see all kinds of violations of the sacred covenant of having boobs, and we're fed up with it.

Whoever is deemed most deserving of this dubious honor shall receive a team of helper monkeys tasked with protecting her breasts from her own poor judgment—be it through pulleys, ties, or other more elaborate mechanisms; the torso equivalent of orthodontic headgear—until such time as she can achieve this effect on her own.

Pamela Anderson

Baywatch, V.I.P., the fantasies of men all over the world

Yes, yes, we know what you're saying: "Pamela Anderson? You think she's misusing those things? She's using the HECK out of them! She is all ABOUT using them. Her whole CAREER is about using them!" To which we say, "Yes, to a point."

When Pammy first appeared on *Baywatch,* that profound exploration of what it means to save lives and respect the power of the sea, her body was—as we sensitive heterosexual women like to put it—totally slammin'. Sure, maybe those gazongas weren't real. Who cared? They worked on her! All that slow-motion! That was some stellar television, and everyone involved should be incredibly proud.

But then they got bigger. And then they got *bigger*. And then they got smaller, briefly. And then they got bigger again. And now they're . . . We don't even know. We know they're not real, but now they don't even quite look like *breasts*. They look like a whole other kind of body part. A freaky body part that doesn't have a name. Like, let's call them . . . FREASTS.

Sure, they're still mesmerizing, but more in the way we were all mesmerized that time Garth Brooks decided he was actually an emo rocker named Chris Gaines. Seriously, *Team America* has less plastic. Do you need us to be blunt? Okay: WE'RE SCARED.

Now, by all accounts, Pam is pretty cool. For example, she named her sons Brandon and Dylan, and as girls who love *Beverly Hills, 90210,* that much is okay by us. And we read her "novel," *Star,* which is hilariously campy and juicy, full of barely disguised versions of what are

obviously true events (she named a Calvin-Klein-underwear-model-turned-actor Tommy Toms, for Pete's sake). Also, we saw her house on *Cribs* once, and the bathroom is really nice. Basically, we kind of dig her. So here's some free advice, Pammy, from the Fug Girls to you: Downsize, okay? Our chest walls ache just looking at those things.

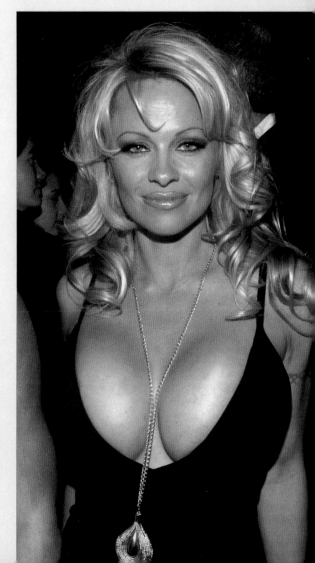

Drew Barrymore

Charlie's Angels, Fever Pitch, E.T.: The Extra-Terrestrial

Drew Barrymore has been famous for basically her entire life, so we've been through a lot with her—the drinking; the drugs; the fire-starting; the brief yet horrifying marriage to Tom Green; and, finally, what we would call her triumphant maturation into a lovely, self-assured, somewhat hippy-dippy adult—if we were the sort of people who used words like "triumphant maturation," which we are not.

Which is why this was so very disappointing:

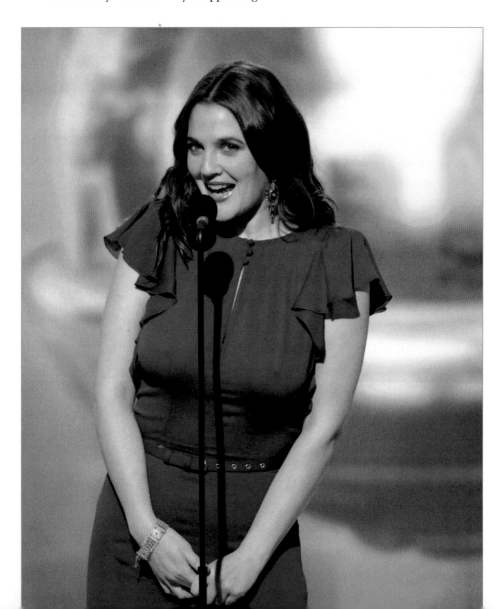

When Drew Barrymore came onstage at the 2006 Golden Globes to present . . . oh hell, who knows what she was presenting? It certainly wasn't Best Performance by a Support Garment (Eighteen Hours and Under). And it's not like anyone was paying any attention to the award at this point, anyway. Instead, everyone within a ten-mile radius of a working television said the same thing to one another: "Whoa." Which was then followed by a variation of, "What is going on with her boobs?" Sure enough, the camera quickly cut to a tight head shot, sparing the home audience any further ocular damage. People watching the awards in high-def must have thought those things were about to swing up and hit them in the face.

But despite the brave work from that fearless production crew, the damage from Drew's Braless Rampage was already done. We got approximately twenty-four thousand e-mails from concerned readers the next day, all of which screamed in different rich linguistic combinations, "DREW'S BOOBS! WTF?" To which we could only reply, "I know, right?"

And then we thought about it. This is *Drew Barrymore*. She wore a daisy stuck behind her left ear for, like, three years straight. She totally lets the girls out for a flap in the breeze *all the time*. It just usually isn't caught on live TV or at close range. And this was the Golden *Globes*, after all. Maybe she was just trying to be punny. It definitely didn't make it right, but it did bring us peace to know that there might be some method to her nipply madness.

The Saturday after the Globes, Drew made a "surprise" appearance on *Saturday Night Live*, bursting into a Weekend Update report on SagGate wearing giant phony, floppy breasts. She berated Tina Fey for making fun of her body (there was a lot of "That's not COOL, guys! A woman's body is SACRED!"), all the while hitting Tina, Amy Poehler, the desk, and the backdrop with her giant foam funbags. It was funny. And here at GFY we love a girl who's a good sport, because it makes us feel better about being so mean.

That said, though, Drew, next time wear a bra.

Kirsten Dunst

Marie Antoinette, the *Spider-Man* series

The curse for most young actresses who get early starts is that their talent gets lost amid rampant reports of careless partying, public drooling, and idiotic sexual conquests in an effort to act ten years older than their actual ages. Kirsten Dunst has managed to avoid that pitfall, indulging in her fair share of on-the-town shenanigans and high-profile romances (Tobey Maguire, *allegedly*, and Jake Gyllenhaal) without ever violating people's respect for her talent

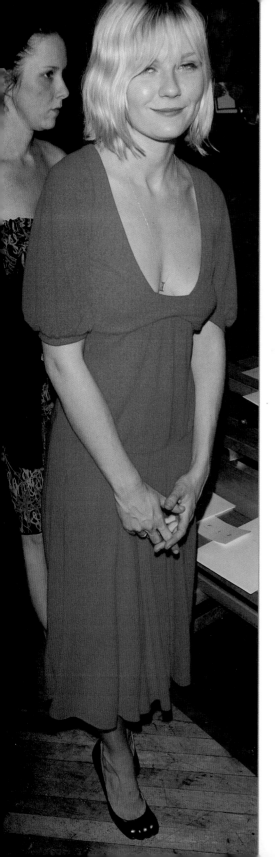

or damaging her professional reputation. Say what you will about her from role to role—brill or shrill in *Bring It On*? Fab or drab in *The Virgin Suicides*?—but the industry adores her fiercely, her box office track record is in good shape, and she never pigeonholes herself or deems herself too Lead Actressy for any smaller roles (for instance, she doesn't have a huge part in *Eternal Sunshine of the Spotless Mind*, and she's supercute in it). Kirsten also, quite frankly, seems to have a great sense of humor, having by many accounts continued to check in with GoFugYourself.com periodically even after we referred to her as looking "mildly to moderately homeless." However, we're made of sterner stuff than that, so as much as we may *wish* Kirsten weren't a prime candidate for this category, we are not giving her a pass. Being a good sport does not mean she's out of the woods with us.

Her particular troubles of late, apart from shying away from hairbrushes with vexing regularity, center around the fact that she's a lovely young woman with absolutely no fear of gravity. To which we must say, "Respect the Gs, Kiki, or they won't respect you."

Kirsten has made a *woeful* selection with this dress, and the forces of nature have responded irritably. This droop enhancer reveals that her breasts are apparently engaging in intimate congress with her waist. No twentysomething's chest should commit an act of surrender so lightly and without any attempt at prevention. Her posture doesn't help, but maybe her body's slight hunch is because she's realizing her couture is a flop, literally.

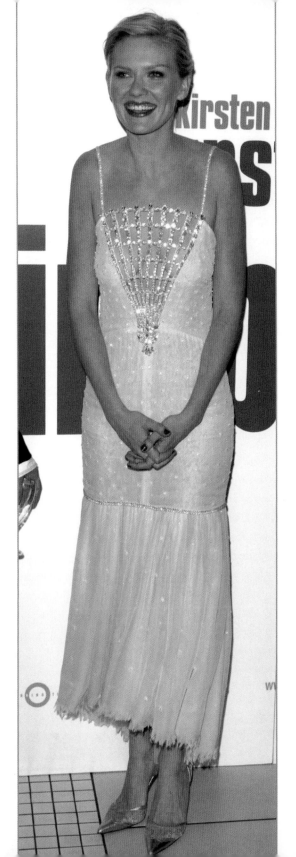

And her issues can't be explained away by saying she's petite of bosom; this pearly gown proves otherwise. You can see exactly how much breast Kiki has, as well as the acreage of torso each has annexed in its respective southward campaign. If they got flattened any more, they'd be more at home on a plate with a side of bacon at IHOP.

Please give 'em a lift, Kiki. Don't treat them like a hooded hitchhiker wandering down the 405 South at night with a pickax hanging out of his backpack. Love your girls better and they'll love you back.

Maggie Gyllenhaal

Stranger Than Fiction, Sherrybaby, Mona Lisa Smile

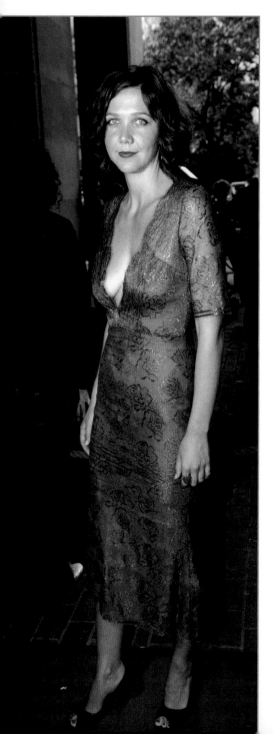

When you look at photos of celebrities day in and day out, it affects you in a lot of different ways. You tend to run into the bathroom and stare at your pores in the mirror for hours; you find yourself wondering how bad it would be, really, to ingest nothing but lemon juice and cayenne pepper for three days straight; you briefly consider enrolling in a daily sweatbox yoga class. Things like that. But mostly you start to notice patterns in what they like to wear. Cate Blanchett gravitates toward metallic colors, for example, and for about three or four years, Kirsten Dunst wore the same pair of pumps—in either red, beige, or black—with every dress.

Maggie Gyllenhaal seems to like plunging necklines, the deeper the better. And while we don't have a problem with that in theory, in practice they make the bras buried undisturbed in her lingerie drawer cry out in an agony that gets louder with every passing day. And it's important to note that these photos were all taken pre-pregnancy, so there's no clemency for a post-childbirth physique trying to snap back. This is the original.

This is very nearly the best thing we've ever seen Maggie Gyllenhaal wear. It's classy, it's clingy, it shows off how lean and sleek her figure is, and it's a great color with her skin tone. And yet her breasts appear so droopy, they're practically jowls. For a girl who digs showing off that expanse of flesh, the fug irony of it is, the dress is flattering to everything *but* the part of her she's exposing.

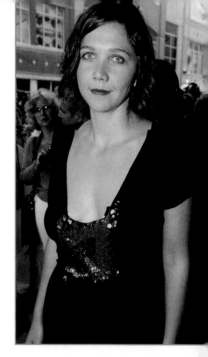

Even *she* seems depressed about it, which is understandable. It can't feel too good to have gravity so actively at work at a formal occasion, yanking your bits downward with mad abandon. The silver lining is that Maggie's waist is about to make some new friends.

Speaking of friends, maybe she and fellow nominee Kirsten Dunst did all their mammarial damage together, back when they were best buds—in those heady *Mona Lisa Smile* days, after Maggie set Kirsten up with her brother, Jake, but before she grew weary of their on-again, off-again dysfunction and decided she and La Dunst weren't going to be pals anymore. That was the era of them sharing the same close-cropped hair, the same physique, the same dimpled smile, the same nipples hell-bent on paying a visit to Naveltown, and the same basic adoration (with different flavors) of moony-eyed Jake.

Despite her penchant for the plunge, Mags's problems extend to plenty of other necklines as well. She could have arranged some strapless or body-shaping help for this dismal blue tragedy, but, then again, she *could* have done a lot of things. Like not wear this dismal blue tragedy.

At any rate, the easy solution for Maggie would be to go to the mall or hop on to those crazy Internets the kids are so wild about these days and buy a bra. Or, better, grab her brother's hot-at-any-age godmother, Jamie Lee Curtis, and have her give a seminar called Take Back the Rack. And if Jamie Lee feels this is beyond even her style sagacity, then at least La Gyllenhaal should have a stylist pick out some stuff that supports the girls rather than leaving them to drop, drop, drop like tears down her torso.

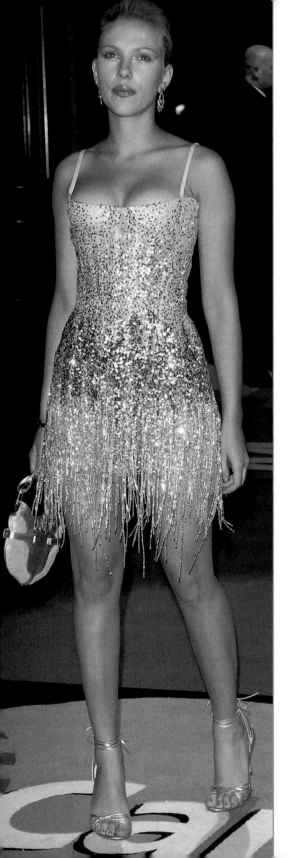

Scarlett Johansson

Lost in Translation, Girl with a Pearl Earring, The Nanny Diaries

The gawky nerd from *Ghost World* has grown up before Hollywood's eyes into a voluptuous vixen whose curves would send Botticelli into an ecstatic coma, yet aren't so ample that the industry has nudged her into the plus-size category ridiculously reserved for girls with the gall to balloon above a size four. In 2006, Scarlett Johansson was crowned the sexiest woman alive by *Esquire*, due in large part to those aforementioned physical hills and valleys—and, we suspect, a photo of her proudly displaying them in a wee bikini. You go, ScarJo.

But, accolades aside, Our Lady of the Creamy Cleavage hasn't always known *quite* what to do with it. And in that sense, she qualifies for this category not on account of her sagitude, but because of the violent ways in which she has sought the opposite effect.

Of course, the Grace Jones makeup and shredded figure-skating costume don't particularly aid her cause here. But when you have what seem to be such nice breasts naturally, why wear something that contorts them into looking as fake and hard as if they were surgically botched? It's painful. Ours are whimpering in empathy.

However, that pain must be like a walk through Central Park on a perfect spring day compared with the cringe-worthy fate that befell them at the premiere of Woody Allen's *Match Point*. That is the scene of her most major offense: the debut of That God-Awful Dress, which ranks, in our estimation, as one of the single worst garments of all time—a tragic, terrible, misguided abuse of fabric that flagrantly disregards the sanctity of cleavage. It's so absurdly sick and wrong that it aggravates us to provide the photograph, and yet, a study of breast maltreatment is incomplete without it.

In a word, YEOW. And she wore that thing all night. Woody probably loved it, since he'd be about eye level with those cups that runneth over, but beyond that, surely even the world's most ardent admirer of cleavage has to admit that this is . . . an error. This is the being-in-the-bathroom-when-you-win-an-Oscar incident of the red-carpet world. It's Chris Webber calling a nonexistent time-out and thus costing his basketball team the NCAA title; it's Bill Buckner failing spectacularly to scoop up an easy grounder at first that would have clinched the World Series in 1986. That gown had a job to do, and instead it completely wet the bed. Her breasts are perched up in that thing like ostrich eggs in teacups. It wouldn't be at all shocking if she pushed a button in her palm and they rocketed toward the paparazzi. (Well, maybe it'd be a *tad* shocking.) What was she thinking? Did she not consult a mirror even *once*? By this point, Scarlett had been nominated for a different pair of globes—the Golden kind—so it's unfathomable that people wouldn't be at her beck and call to advise her and correct this.

Please, Scarlett, throwing a diva trip and demanding a dress that fits would be *so much better* than putting yourself—and us—through this again.

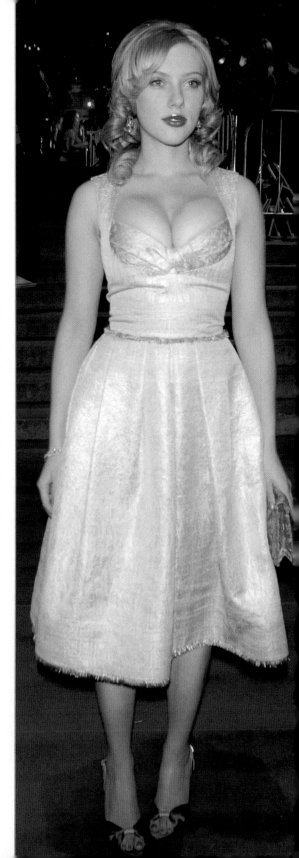

AND THE SAG
AWARD GOES TO . . .

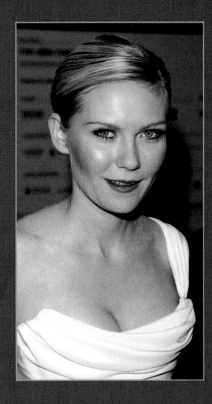

We would like to extend dubious congratulations to **KIRSTEN DUNST** for living her life as if she were the live-action embodiment of the Seven Mammarial Dwarfs: Droopy, Saggy, Floppy, Flappy, Slumpy, Wilty, and Wack. It's especially jarring when you see a photo in which she does get it right, illustrated by the graceful bodice on the white gown pictured here, which hits the exact right amount of support.

Her boobs look ample yet delicate. She has just the right amount on display to please the oglers, while still preserving a sense of the unknown. (As a bonus, her hair and makeup totally work.) It's this cheerful success in the breast-respect department that illuminates how egregious her failures really are. She can do it, but she just doesn't always feel like it.

The Care-frontations

Most

Likely to Require

a Tough-Love

Fashion Intervention

Look, we're not just mean bitches who hate everything and think everyone is hideous. Sometimes, in fact, we despair. That's right: We feel deeply. And one of the things that makes us feel the *most* deeply and the *most* despairingly is when a normally chic and well-dressed individual—male or female—appears in public wearing totally heinous outfits. It's like the clothing equivalent of a piano prodigy deciding to chop off several fingers, or Gisele becoming a competitive eater: such a terrible waste of potential.

ut of that despair comes this category. This, more than any of the other Fug Awards, comes from a place of love, concern, and "Good God, child, pull it together!" The winners—one male, one female—are being recognized not because their fugliness is so awesome or so undeniable. In fact, they are not being recognized at all so much as they are being warned. This nomination is our way of sitting down with them amid their circle of closest friends, loved ones, pets, and paid companions, and whispering, "Clean up your act, or you're gonna end up taking home another Fug Award someday, and that time, it's *not* going to be the one where we give it to you because we care. It's going to be one of the mean ones."

So who's going to take home the Golden Band-Aid?

FEMALE IN MOST IMMINENT PERIL

Here we've got a tiny little actress who used to spend almost every day with a dude who was on *Just Shoot Me!*; a dead-eyed starlet who was groped onscreen by a stalker in a mask; a very famous actress who used to make out with David Schwimmer at work and Brad Pitt at home, and then lost both of them in relatively quick succession; a comedienne turned actress who *also* used to make out with David Schwimmer; and a former-pop-star-turned-TV-host who's often bedeviled by accusations of drunkenness and who would probably *love* to make out with The Schwimm because, hey, it was good enough for the other two.

Paula Abdul

Former pop star, *American Idol* judge, often rudely accused of being hammered

Poor Paula. She gets no respect. Back when she was a singer, everyone turned up their noses at her totally manufactured, Pro-Tooled pop, but then secretly listened to the cassingle of "Cold Hearted" while getting ready for homeroom. If only we'd known then that manufactured, Pro-Tooled pop was the wave of the future. Paula might have seemed more like a visionary, instead of the kind of girl you mock in public and make out with in private. Anyway, after a series of guilty-pleasure hits (come on, "Straight Up" is really good), she disappeared for a while. And then she made a huge comeback as one of the judges on *American Idol*, prompting another chorus of "Why is Paula Abdul judging a singing contest? She can't sing"-type comments. But little did we know we'd soon forget that Paula can't sing, in the wake of learning that Paula can't *speak*. While *American Idol* Judge One, Randy Jackson, typically tells the show's contestants that they "did [their] thing," refers to them as "dawg," or informs them they were "pitchy," and Judge Ultimo, Simon Cowell, generally restricts himself to a blunt "That

was terrible," Paula's comments tend to sound like she's reading a book jacket badly translated from Japanese: "You have been flying with the unicorns and when the parrot comes home, then you'll know what I was telling you before. Why? Because you've milked your own heart, and that's why the pandas are here."

Even worse are Abdul's promotional tours. Generally, while on a junket or talking to the press, she seems like she might have maybe had a little liquid lunch. Or a lunch that comes in pill form. We don't *know*; we're just *speculating*. That's how it *looks*. Although she strenuously denies any abuse of mind-altering substances—and she might have a point, in that it's possible she has no mind to alter—she often certainly *seems*, in our opinion, kind of . . . out of it. And if she is indeed under the influence of something, be it DayQuil or something stronger, it actually would explain why she occasionally pops out of the house looking like she got dressed in the dark.

You see, for all her kooky behavior, Paula often looks adorable, ladylike, and pert. But just when we're getting comfortable, she emerges in something like this:

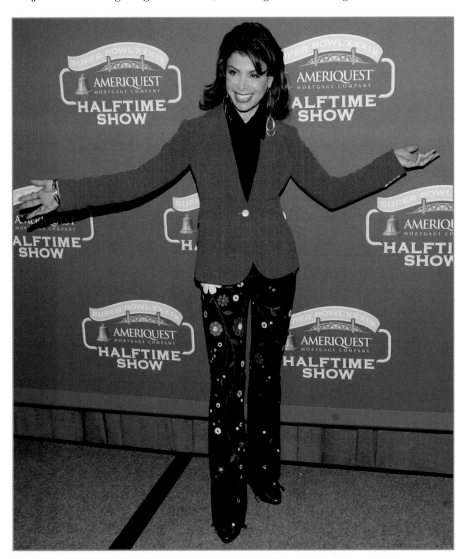

Where's her top hat? Where's her whip? Where's her elephant? What do you *mean* she's not the ringmaster of the Cirque de Sogay?

If Paula actually *were* a flamboyant circus madam—which her lawyers assure us SHE IS NOT—it would explain why she appears to be mere moments away from ushering us in to take a gander at the bearded lady, with whom she would be happy to arrange an, ahem, *encounter*.

Meet her behind the elephant truck, and bring cash.

And when spring comes to the circus, you can check her out in this traffic-stopping little number, as designed by Major Accent Highlighters.

This must be what they wear when they're lassoing the unicorns in the circus of her mind. The bright colors stun the poor creatures, and then they just wander into Paula's unicorn holding area, where they frolic in the—oh no. Now we're starting to sound like Paula herself. We're terribly sorry. Just do your thing, dawg. Er, Paula. Whatever. Oh God, we have to move on now.

Jennifer Aniston

Friends, The Good Girl, The Break-Up

Remember that awesome red dress Jennifer Aniston wore to the Emmys that time? . . . You don't? Well, that's hardly a surprise: It happened back in 2001. And at every other event since then, Jennifer has almost exclusively worn black, cream, or beige.

Seriously. Are you asleep yet? It's no wonder everyone's convinced she's depressed.

ex Brad Pitt's happy family, and weeping your way through yoga were good smoke screens for the fact that you are becoming as bland as a milk-flavored milkshake?

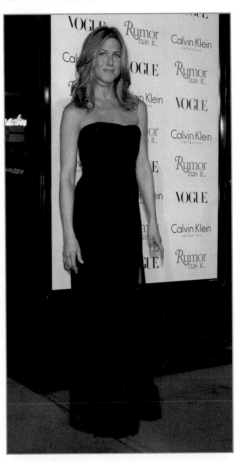

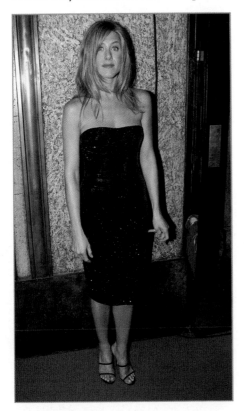

Oh, don't look so surprised, Jen. Did you think we wouldn't notice? Did you think all your hearty public denials of becoming codependent on Courteney Cox, dating Vince Vaughn, breaking up with Vince Vaughn, envying your

It's not that you don't *look* nice in your clothes; this black sheath is elegant and flattering. It is *also*, frankly, totally lazy. Now, that's not to say we can't get behind a little black dress, or even a big black dress, but not when the wearer's closet seems to be filled

with nothing else. It's all about context. Were the bookies in Vegas at all concerned with fashion, it'd be odds-on that at any given event, this color-averse dullard would show up in black.

to deny as coyly as possible. But really, the mere sight of another colorless, knee-length strapless number makes us wonder whether she's so indolent that she's content to rest on her figure, her tan, and the public's perceived fascination with her hair, as if those are accessories enough to brighten up any outfit. Dear Jen: You're wrong. P.S. Where do you do your shoe shopping?

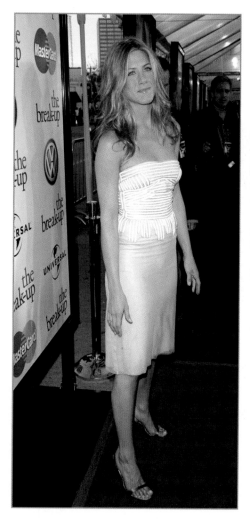

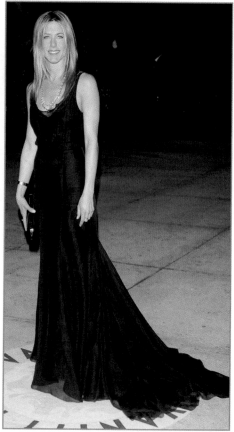

On the rare instances Jen deviates from her bleak streak, it's only to don something *bleached* of color. Of course, this particular forced attempt at lightness of spirit in 2006 dovetails with her having a summer comedy to promote and a romance with her costar

Not even the Academy Awards could inspire her to try a glamorous updo or a rich, imaginative hue. If ever there were an event that encouraged standing out in a crowd, it's the Oscars, and yet poor sad Jennifer Blahniston couldn't deliver.

So here's the deal, Jen: Wake us up, please. Shake us from our slumber. Hell, even a haircut or tinting might be enough; it worked before, didn't it? See, the thing is, we used to like you. We used to sympathize with you. We think it's possible we could feel that way again, because we are bothered enough to want to sit you down and shake some life into you, but right now you're kind of blowing it. The more boring beige or beat-down black you wear, the more impatient we grow at your inability to kick ass and shove all the magazine covers back in Brad's face. You're not doing a very good job with the whole revenge PR thing, Jen, and the more pathetic things look, the less we care if you ever fix it. Nobody loves a sad sack, lady. Do *something* resembling *anything* before we get too bored to care.

Kristen Bell

Veronica Mars

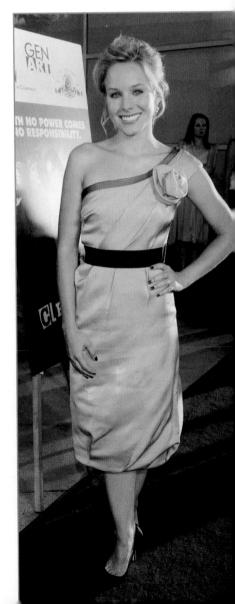

In the past we've ridden Kristen Bell pretty hard for wearing clothes that are way too old for her, as if she's an aspiring fifth Golden Girl but with none of Blanche's charm, Rose's cheerful innocence, Dorothy's world-weary wit, or Sophia's enormous trifocals.

Fortunately, Kristen seems to have taken at least some of that advice to heart, as she's started attending fashion shows that present a host of cute, chic cocktail dresses, and then wearing many of those outfits herself. The trouble here, though, is that Kristen still hasn't learned a key lesson about how to clothe a diminutive body: There is a very, very small margin of error when it comes to your hemline, and that margin is the difference between looking sleek and, well, stumpy.

Badly tailored dresses—as demonstrated by this wrinkled satin gown, which is confusing, unflattering, and overdone—can frumpify you chiefly by hitting you at the widest part of your calf, thereby accentuating its width rather than showing off its shapelessness. It's the bridesmaid dress your cousin Marge swore you could wear again if you just took it up a bit, and, sadly, you listened. Your ankles will forever hate you for it.

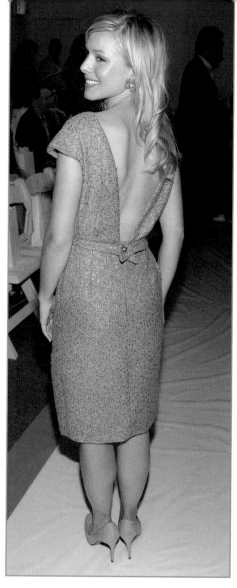

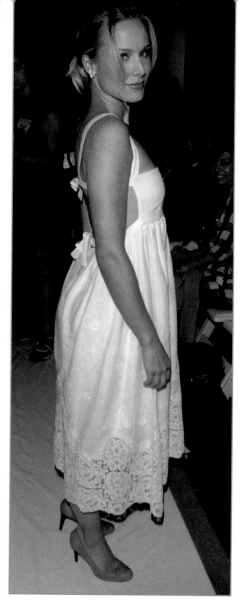

Aw, Kristen, you can turn your back to us all you like; it doesn't change the fact that your skirt is still too long. Perhaps she's trying to be cheeky, as if someone just said to her, "That tweed thing adds ten years to you," and she replied, "Oh yeah? Well, get a load of THIS," and turned around to flaunt her braless back cleavage. And the back *is* actually kind of cute, but, honey, even the heels don't erase how squat you look.

This country frock, which would be more at home as one of Jennifer Love Hewitt's eccentrically old-school nighties on *Ghost Whisperer* (apparently she likes treating the spirits to a nice transparent, braless jiggle), makes Kristen appear even shorter than she actually is—and, as an added bonus, there's a whiff of *Little Maternity Shop on the Prairie* about it. She looks both pear-shaped and

six inches tall. And while there's nothing wrong with being wee—we *love* tiny things, like mini bottles of condiments and teensy cupcakes and Ron Livingston—you do not want to create the illusion that somebody just pushed down on your head really hard until part of your legs retracted.

Kristen, have you learned nothing from the plucky sleuth you once played on TV? Veronica would relentlessly sniff out the right answer, no matter *how* smug, superior, and joyless it made her (which was: a lot). Study your skirts, look for clues as to how they could hit you in a more flattering way, and then SOLVE THE CASE, already.

Emmy Rossum

Phantom of the Opera, The Day After Tomorrow

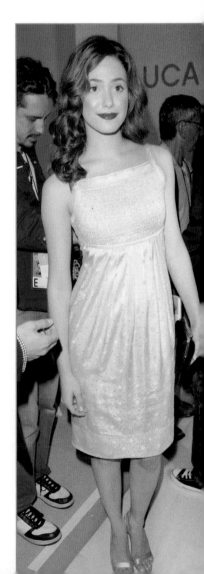

If you're not familiar with her, the bullet on Emmy Rossum is that she's a very young, impossibly fresh-faced and wide-eyed actress who is also a classically trained opera singer. She exudes so much sweetness from photo to photo that it almost seems forced. Which it might well be, actually. But we'll say this for Emmy: You never hear about her flipping off or attempting to run over the paparazzi; falling on her face while staggering to a car and then proving she is anatomically correct while getting in; bragging about all the men, young and old, who've tended her private garden; or texting illiterate screeds on her BlackBerry. So she's clearly doing *something* right.

Lately, though, that "something right" is most decidedly not her makeup. Although Emmy has long cultivated a bit of a so-porcelain-she-can't-be-real air, she now consistently rejects looking like a living, breathing girl.

Somewhere on the way to this Luca Luca show, Emmy Rossum slipped into a coma. There is no life in this face whatsoever, and with the frock blending in so seamlessly with her fair skin—which is admittedly flawless, but still; we are pale, and as of yet no one has accused us of having a chronic wasting disease—the eye is drawn straight to the crimson gash on her face masquerading as lips. It's as if all her body heat were channeled there, leaving the rest of her clammy.

If we didn't know better, we'd suspect that the real Emmy Rossum was driven to a life of seclusion by the trauma of a pimple, and has instead replaced herself with a series of relatively accurate if expressionless living dolls designed for her to cash in on her fame while she actually sits at home in darkened rooms wearing caftans, turbans, and huge sunglasses; chain-smoking cigarettes through a long filter; and watching *Murder, She Wrote*.

At a *Glamour* magazine party, they whipped out the monochromatic Child Bride Shotgun Wedding model. Perhaps they grabbed this one off the assembly line too early, before the artists had finished properly painting her features.

Meanwhile, the Schoolgirl Fetishist Model has, we hope, landed on the reject pile. Even its creators must realize that squeezing her into a crinkled black satin frock more appropriate for a six-year-old was kind of creepy. She looks like *Alice in Six-Feet-Underland*. It's unclear why her team stuck with the shiny porcelain pallor, unless Rossum Enterprises was campaigning to land her the starring role in a *Snow White* remake and they wanted to prove she could look pretty while colorless and comatose.

We're both fair-skinned lasses ourselves, and we don't think that all people of lesser pigmentation should slap on four tons of burnt sienna base makeup in the name of looking lively. We are actually pleased that Emmy has not tanned herself into oblivion. But the robotic, creepy calm that she's always exuded is only exacerbated by her remaining as pale and blank-looking as possible, and we're starting to wonder if in ten years she'll have gone on a hideous crime spree that has us all saying, "But she seemed like such a plain, *placid* girl. Who knew she even had the *energy* to run around town shooting old ladies up the nostrils with a nail gun?"

Aisha Tyler

Talk Soup, Friends, Ghost Whisperer

Aisha Tyler has made a nice little career for herself, starting out on *Talk Soup*, finding her way to *Friends*, and then getting herself killed off on *Ghost Whisperer* when a plane landed on her head (for real). She seems smart, and goodness knows, she's got a fantastic body. Her legs are longer than the two of us laid end-to-end. There is a lot of awesome going on with this one, which makes it all the more painful when she screws it up.

We're sure Aisha looked totally adorable in this little number twenty-five years ago, when she was in kindergarten, when it was appropriate. And while we, too, would love to find the perfect bloat-hiding outfit to wear on those evenings when we've got a big night of beer and pizza ahead of us, but when you're climbing the ladder of Hollywood starlets, it's probably advisable to show up at the Golden Globes looking more va-va-va-voom and less Damn-I-shouldn't-have-eaten-those-hot-wings.

That seems to be a running theme with Ms. Tyler, however. This shirt is ready-to-wear's salute to tenting. What's she got going on under there? Is she smuggling a turkey into the event for later snacking? Does she have a beach towel stuffed into the waistband of her capris in case a game of blanket bingo breaks out? Is she trying to fool the editors of *Us Weekly* into believing that she's knocked up, so as to get some "Aisha's Baby Joy!"–style coverage? Either way, she's just made herself look far wider than she actually is. And while we are big fans of being comfortable— we're wearing giant muumuus right now, actually—there is a time and a place for concealing your waist, and it's not the red carpet. It's the privacy of your own sofa.

What did we JUST say? It's the PRIVACY of your own HOME, not at a FASHION SHOW. We can't think of a worse place to decide to chub it up than a venue primarily inhabited by Amazons weighing ninety-five pounds. The great tragedy, of course, is that Aisha Tyler doesn't have anything even approximating a weight problem. She just dresses like she thinks she does, all waistless and tenty, and she's making what wasn't an issue to begin with into a huge one. If Jennifer Love Hewitt is the ghost whisperer, then Aisha became, during her stint on that show, the waist whisperer: No one can see it but her.

AND THE GOLDEN BAND-AID GOES TO . . .

We can see the headlines now: JEN'S FUG AWARDS PAIN: FIRST I LOST MY MAN, THEN I LOST MY LOOKS. But that's exactly the point. At the moment when JENNIFER ANISTON most needed to appear on the scene looking mad crazy hot, she . . . did nothing. She pretended nothing was happening. And while we don't think she should have attacked Angelina Jolie with a knife or started crying on the red carpet or erected a billboard in front of Brad's Malibu house reading DROP DEAD, ASSHAT, we do think it would have done her a world of good if she'd ditched the widow's weeds and reinvented herself a bit. Look, we've all been heartbroken. There is no better way to tell the world, and yourself, that you don't care about that stupid douchebag who left you than to show up in public looking awesome. Because then people know you're not rolling around on your sofa every night, watching *Grey's Anatomy* and crying into a barrel of ice cream. Also, the douchebag will feel sorry that he's no longer grabbing your hot ass. It is crucial that both of these objectives are achieved in order to successfully get through a breakup of this magnitude. And Jen's done NEITHER of them.

MALE IN MOST IMMINENT PERIL

In this subcategory, the gentlemen who need to fire their stylists STAT include: an *American Idol* contestant passionately beloved by America's middle-aged; a Spanish-language singer mysteriously beloved by J. Lo; a boy wizard (not the one you're thinking of) deeply beloved by readers; a boy comic who, we're sure, is beloved by his mother; and an actor famous for playing an agent, who, we all know, are often beloved by no one.

Clay Aiken

American Idol, the secret scrapbook that your mother keeps under the bed

Clay showed up for the season two auditions of *American Idol* looking like something of an oily dork: unwieldy spikes in his hair, unflattering glasses, and a real, tangible aura of geek. And yes, Claymates, we know it takes one to know one, and our answer to that stunning logic can only be to remind you that we're rubber and you're glue. Anyway, Clay had a booming voice and a nerdy confidence about him; plus, frankly, he was a stylist's wet dream. Naturally, he was cast. And he came in second. And, of course, got himself hipped up but good.

See? This Clay, the Old New Clay, is a gentle but trustworthy Clay. His image says, "It's okay, sweet lover— I won't put my hands anywhere but in yours as we walk together on this profound journey of the heart. Also, treasured lady, have you seen my pomade?" This is the Clay who captured the hearts of weeping mothers and grannies all across America who hoped their daughters would end up with a nice boy like him who could sing "I Honestly Love You" at their lavish country wedding.

Unfortunately, this is not the Clay we got to keep.

Soon we were treated to Fraternity Sleaze-ball Clay, who squeezes his beer bloat into Banana Republic formal wear and slouchy jeans, combs his hair over his forehead and styles it with the natural grease the Lord gave him, and appears to smell faintly of either Old Spice or stale cheese. Last night he stocked up on roofies en route to a party at which he did a twenty-second keg stand and then, miffed at his relative failure, retreated to the kitchen and gobbled up an entire pan of Jell-O shots.

After that we got an incarnation of Clay molded from two parts Paul Reubens and one part k.d. lang. The result was a Clay far smarmier and self-satisfied than he should have been, considering that he both stole his hair from a man who got arrested for indecent exposure *and* somehow looks more feminine than k.d.

Then he grew out the Reubens coif into a shaggy sensitive artsy-boy 'do—very Josh Groban, but without the curls. This Clay gazes at you in sultry confidence, but it comes with a creepy, smug sense of entitlement. He's *certain* the electricity you'll feel at the chance to brush this outrageous mane off his forehead will send you straight to a bearskin rug in front of a roaring fire, Kenny G playing gently in the background, where you'll stare deeply into his eyes and fondle his expertly highlighted waves. "I couldn't be intimate with someone who doesn't feel things as deeply as Teddy Pendergrass does," he would husk, right before turning on the secret wind machine that's aimed exactly at where his head will be when he begins whispering sweet nothings to you about the future, and romance, and no-crunch hairspray.

Which is to say, all of these incarnations are a little smarmy for our taste. And not a little seedy, to boot. These images have us worried about his drifting hands and fearful that he's undressing people with his eyes. We may not know what we want all the time, but we know what we like: our Diet Coke cold, our *Dynasty* full of Joan Collins, and our Clay Aiken squeaky clean and asexual. Is that too much to ask?

Marc Anthony

Singer

J. Lo has had a long string of bad luck with the dudes.

Husband number one, Ojani Noa, tried to sell a tell-all book about their relationship that allegedly painted her as a cheater. (She eventually had to sue him. As one does.) Then she dated Sean "Puff Daddy/Puffy/P Diddy/Diddy" Combs for a couple of years, and she somehow ended up getting involved in some crazy shoot-out at a club and got charged with felony gun possession, of all things. So that didn't go very well even though the charges were dropped.

Then she married Cris Judd, and in the tradition of very famous women romancing

their backup dancers, the union lasted less than a year. This led to her infamous courtship of Ben Affleck; you may recall how triumphantly *that* little dalliance went.

Finally, she married singer Marc Anthony in 2004, and we have to say, it seems to be working out okay for her this time. She's always smiling, and we're impressed that she hasn't stopped eating amid constant speculation that anytime she's wearing something that isn't skintight, she *must* be harboring a secret fetus. Step off, people. Sometimes a girl just needs carbs. In fact, we think Jennifer Lopez Noa Judd almost-Affleck Anthony has never looked better.

Marc, on the other hand, has never looked *deader*. Exhibit A:

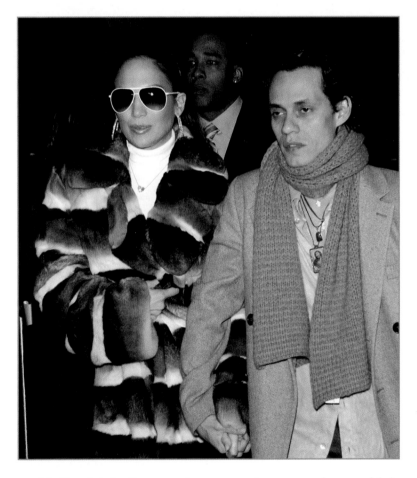

It's like she's leading around a consumptive as part of some celebrity outreach program. "Maybe he's sick!" you might exclaim. "Maybe he has a cold! Maybe he just doesn't look that good in oatmeal!"

Okay. Allow us to present Exhibit B.

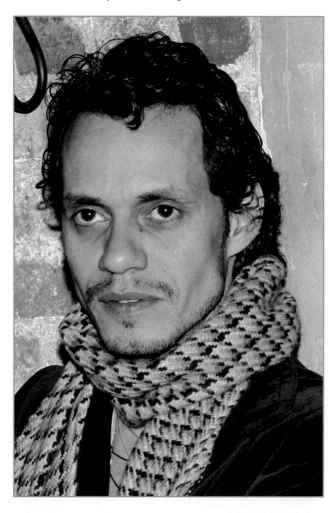

"God, I'm so tired," he seems to be thinking. "I'm so run-down. Maybe I should eat something. It's been three weeks since dinner. Also, it's so chilly. Why can't I get warm? Why?" To which we say, Marc, you're not wrong; you *do* look a bit peaked. Have you considered having your doctor check your blood's iron levels? And if those numbers are normal, have you considered that maybe you might not HAVE all your blood? Your wife has been blooming lately. Is it possible that she's been supping on your life's nectar, unbeknownst to you? We would never say that she is a vampire, but you've been looking like a zombie lately, and surely that doesn't appeal to the scores of ladies who swoon at your emotional Spanish love songs. We suggest, if not the ministrations of a skilled physician, then at least some bronzer and a sandwich.

Rupert Grint
The *Harry Potter* films

Put down the poison pen, *Harry Potter* fans. We love Rupert Grint, who plays Ron Weasley in the *Harry Potter and the Insert Fantastical Wizard Adventure Here* series of films. He's got the exact right mixture of loyalty and dopiness required for the role, not to mention the all-important red hair. More than almost anyone else in this category, we just want to take Rupert Grint under our kindly, loving, sisterly wings and fix him. Because we think he's swell, and because he really, really needs it.

Seriously, the kid does not know what to wear to an event. Behold:

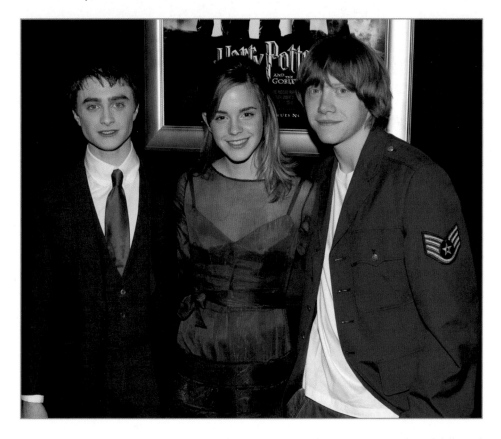

Three dressy events, three big old blunders. In the first photo, Daniel Radcliffe and Emma Watson, Grint's *Harry Potter* costars, both look adorable and appropriately formal. Rups looks like he's on his way TO a movie, not like someone attending the premiere of a movie in which he stars. That goes double for take two, where he is photographed with

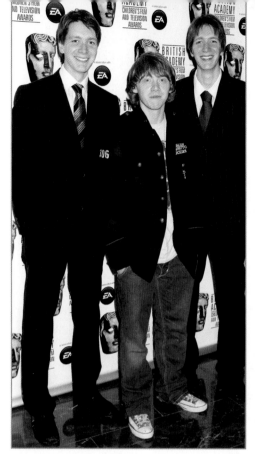

James and Oliver Phelps, the twins who play his older brothers in the films. Their suits are sharp, yet poor Rupert—who always looks so abashed, which is sweet, really—is again just slumming it in his jeans and trainers. And while we're all in favor of kids being kids and whatnot, *this* poor kid needs someone to dress him suitably for a posh occasion.

That someone, however, should *not* be drug-and-Kate-Moss-lover/musician Pete Doherty, who, it appears, styled Rupert in the third photograph. The one thing worse than a teen actor showing up looking like a schlub when his costars look like the proverbial million bucks is a teen actor showing up looking like a drunk. Now, let us be very, very, VERY clear: We are quite sure that Rupert is NOT drunk, nor A Drunk. We think he's just exceptionally slobby. But the last thing he needs is to be compared to a man who falls asleep in puddles of his own vomit, and Rupert's messy shirttails and tie make him look like he's been attending the Doherty School of Public Intoxication.

What we'd really like is for someone to take sweet Ron Weasley here by the hand and trot that kid over to High Street and buy him a suit. And when it comes time for him to leave the house in it, supervise him and make sure that everything is in its correct place. This person could be his mum, a stylist, the guy who lives down the street, the bloke who owns the pub on the corner, the ghost of Richard Harris, or Lord Voldemort himself. We have no preference.

Jamie Kennedy

Scream, Scream 2, The Jamie Kennedy Experiment

The last time we saw TV prankster Jamie Kennedy out and about with any kind of arm candy, it was . . . well, quite a while ago.

He had his lovably sloppy tousled hair, that rumpled suit, and a Sherilyn Fenn–esque brunette to wrap his arm around; the effect was exactly what you'd expect from a guy who charmed us as the dorky film-obsessed Randy in *Scream* and used that to springboard into edgier improv on The WB. Yes, we know that "edgy" and "The WB" go together about as naturally as hot dogs and tile grout,

but Kennedy found moderate success there with a hidden-camera-style show, *The Jamie Kennedy Experiment*, where he'd dress up as various (and admittedly sort of irritating, on occasion) characters, and mess with people's heads. So his image was basically just clean *enough*, yet a touch wild. Like, "Come on, parents, let your kids watch my show. I promise I will only moon them twice."

Now, though, we can't figure out *what* his message is.

But based on his pasty, bloated skin and scraggly hair, we are *guessing* he's encouraging kids to prowl graveyards at night and hopefully get tangled up with the undead. (Perhaps he has been watching the Draining of Marc Anthony with more than just passing concern.)

Or perhaps he's trying to entice the devil to buy his flesh in exchange for a good night's sleep, which appears to have eluded him for about three years.

As, we fear, have the ladies themselves. Indeed, Kennedy is the anti–Ashton Kutcher: One is a jokester scamp who groomed himself into adorable scruffiness and then bedded and married a total hottie, while the other is reduced to making public appearances with underwear on his face.

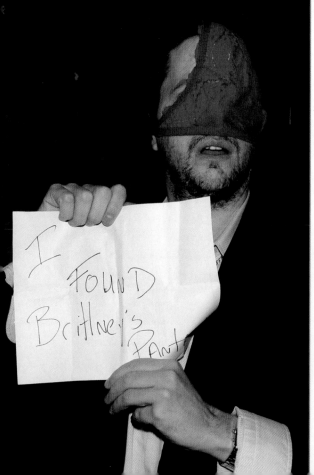

It's a sad, sad day indeed when the closest he can get to a public date is to buy a pair of panties, put them on his head, and claim they were left there by a pop tart who was right at the beginning of one of her most pathetic life cycles. Also, Jamie, you spelled "Britney" wrong. Even *she* doesn't make that mistake, although it probably took a while to get to that point, and we're all very proud of her efforts.

But back to the matter at hand: The evidence clearly points to a terrible descent into skeeviness. His most recent special as of this writing appears to have been aptly titled *Unwashed*. Hopefully for Jamie, he'll snap out of it and claw his way back to something that's not so hygienically dicey and is also less likely to result in his releasing his own line of panty hats.

Jeremy Piven

Entourage

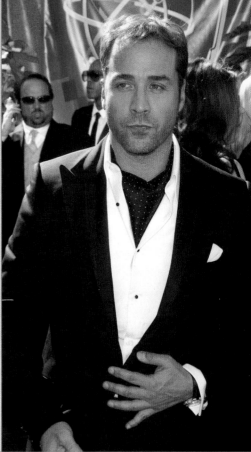

We are suckers for men in suits. There's nothing more delightfully classic than a clean, well-tailored two-piece or, better, a tuxedo. So for us, awards shows are like walking into a giant candy store that's dispensing man-flavored jelly beans.

Which is why we were so disappointed in Jeremy Piven at the 2006 Emmy Awards.

It's not acceptable to roll out of bed and onto the red carpet without so much as a swish of Listerine. The open shirt doesn't appear stylish so much as lazy (and possibly sweat-stained), and the ascot is less a refined addition to a progressive tuxedo than something that looks like it's hiding three giant hickeys. We'd suggest that his mother must have been mortified, but she was his date, so either she didn't mind or her poker face is dangerous and we want to take her to Vegas.

At least Adrian Grenier, he of the fluffy hair and stubble that are synonymous with his *Entourage* character, Vincent Chase, managed to put on a pin-striped suit and tuck in his shirt at this event. Piven went with dark jeans and a button-down he may well have picked up off the floor from a few nights before, when he wore it out to Hyde and perspired through it all night on the dance floor after, say, licking Jägermeister off the neck of a *Deal or No Deal* girl.

For the 2007 Golden Globes, Jeremy did manage to pull out a cleaner-looking suit, but he still couldn't be arsed to shave his weak two-day growth. Which, you know what? Do it for your mother, who seems to be your constant date at these sorts of functions. If you were Kiefer Sutherland—whose gleaming gold stubble only makes us love him more, because no one works harder to save the day through very traumatic Secret Pain than our boy Jack Bauer—then we might give you a pass. If you were Josh Holloway, or Matthew Fox, and needed authentic facial outcroppings to reflect your alter ego's problem of being stranded on an island in the South Pacific, it wouldn't bother us as much.

Is that why you leave the scruff, Pivs? Because you basically play a douchebag on *Entourage*, so you figure you might as well leave it all hanging out when you're off the set as well? Because we have news for you, Jer: You could regrow that weak little scratch in about a day and a half. And also, it's stupid to look like a douchebag on purpose. Won't someone think of the bloggers? We've got so many organic douchebags to deal with already.

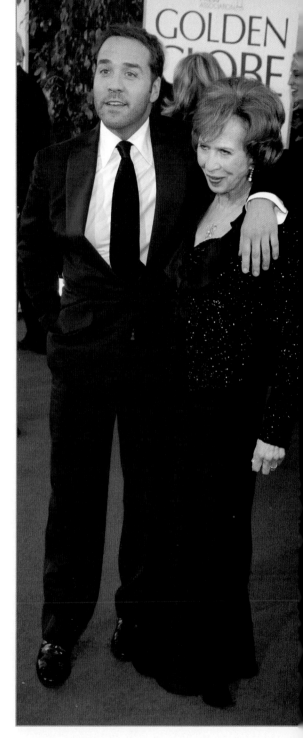

FUG

AND THE GOLDEN BAND-AID GOES TO . . .

He is young. He doesn't live in Los Angeles. And he isn't in the tabloids every week. Ergo, RUPERT GRINT still has a fighting chance to pull it together and turn into a dashing, dapper man—and, in fact, we fully expect that he will be able to do that. The kid just needs a little guidance. Can't he call up Hugh Grant and ask for help? (Don't all those actors know each other? England's small.)

Besides, although there's no excuse for showing up at a formalish event in jeans, it's not like we didn't have our share of screwups when we were kids. Let's just say there were multiple pairs of color-coordinated scrunch socks involved. And maybe lots of acid-wash. So we sympathize with him. But more than that, we believe, like Whitney Houston, that the children are our future. If someone would simply teach Rupert well, he could lead the way.

Put It Away

★ 4

Most

Underclad

and

Overexposed

This distinction goes to the desperate exhibitionist who, for reasons of overexposure either of the flesh or of the persona, or both, needs desperately to revisit her sense of style.

B y our giving this award, we—and the world—are imploring the winner to, in essence, shove off and put on a jacket and/or pants. Past winners would have included Geena Davis, for her famous transparent awards-show couture; Jennifer Lopez, in honor of that plunging green Versace cape she called a dress in 2000 (and all the bra tops she wore when she was Sean "Puff Daddy . . . We Think" Combs's other half); and Lil' Kim, the scantily clad rapper who, in 2005, was indeed quite literally put away . . . in prison.

Pamela Anderson

Baywatch, that famous sex tape

Saying that Pam Anderson has a habit of walking around with too much of her business sticking out is hardly like saying she discovered cold fusion, or cured cancer, or has decided to chuck it all in favor of taking a vow of silence and devoting herself to a life of poverty and humility alongside the rest of the Carmelite nuns. Running all over town with her junk hanging out everywhere is pretty much her stock in trade. We've already nominated her for a Sag Award based entirely on the pure enormity of her breasts, so we're well aware that she's got a lot of lady with which to work.

But there's Just Having Abnormally Enlarged Breasts, and then there's Taking Your Mad Crazy Jugs and Shoving Them Up In Everyone's Face All the Time.

First of all, we can see your nipple. Second of all, that shirt makes your breasts look like they're about to break free of your body and go on a killing spree, destroying any innocents in their path. And we can SEE your NIPPLE.

When you subtract the Killer Melons, the extreme tan, the metric ton of eyeliner, and all that big blowsy hair, Pammy is quite cute. It's just a fact. And, despite the dumb blonde act, she's far from stupid. So why does she persist in making public appearances dressed like a working girl? Why does she believe that we need to see her areolas in order to find her interesting? We would be fascinated by her on-again, off-again love triangle with Tommy Lee and Kid Rock even if she were wearing a turtleneck. At this point, we're well aware

of what's living underneath her blouses, and, quite frankly, it might be a point of interest to cover them up. Imagine the tabloid headlines! FROM SUPER-FREAK TO SUPER-CHIC: PAMMY'S NEW LOOK! or BYE-BYE, BOOBIES: PAMMY'S MAMMARIES GO UNDERCOVER! or AMISHMANIA! PAMMY TAKES THE BONNET, TOMMY LEE HITS THE ROAD. AGAIN.

The media would jump all over a Pam Anderson makeunder, because it would prompt so many questions. Why? How? And whose high-necked blouse is she wearing? Putting it away would create a news frenzy that PAM ANDERSON LEAVES HOUSE, FLASHES NIPS never could.

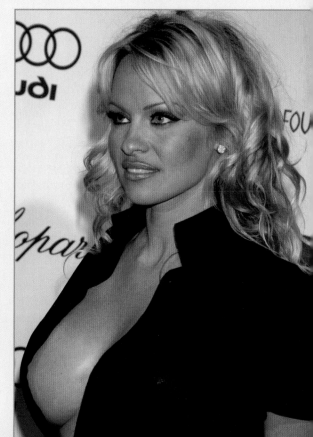

Kevin Federline

Britney & Kevin: Chaotic, the tabloids, our nightmares

Let's get one thing totally clear: No matter how sainted Britney's post-divorce misdeeds made him look, we—and indeed, the entire human race—still do not particularly like Kevin Federline.

Seriously, has there ever been a celebrity spouse more despised? Eva Braun fans were probably none too thrilled when she hooked up with Hitler, but other than that, we're drawing a blank. It's hard to root for a man who abandoned the pregnant mother of his children to gallivant around Europe with a then-sheltered and none-too-bright pop star, then marry said pop star and run through a big old chunk of her cash trying to fund his dismal "rap" career. To paraphrase Kayne West, we ain't saying he's a gold-digger, but he ain't marrying no brainy, penniless girls, neither. Indeed, our initial plan was to create a category for him called "Beyond the Point of No Return," nominate him three times, and then deny him the pride of victory because we don't want him to have the satisfaction of calling himself the winner of anything—even if his only competition was himself.

But then, fate flipped the coin. Britney rebelliously dove into a cesspool of bald, boozy, seminude antics, turning the tabloids against her and her parenting skills and giving K-Fed an opportunity to buff his tarnished image. With a few extra quiet nights at home, some carefully placed quotes about responsibility, and the rumors that Lynne Spears trusted him enough to join forces with him in getting Britney into rehab AND snuck over there for visits with the kids, suddenly the man who dubbed himself "America's Most Hated" didn't look that bad.

Still, we're not entirely convinced yet that K-Fed is motivated purely by altruistic paternal love for his loin-fruit, and not merely the prospect of juicy alimony checks as bloated as his ex. And that's why we're entreating him to Put It Away: Shed the old K-Fed—the one with the scuzzy duds, skeezy visage, and embarrassing songwriting career—and man up properly.

In other words, no more capes.

Is he in costume here? And if so, who is he supposed to be? The Great Sperminator? A vampire, sucking not blood, but rather all the money out of his wife's bank account and the life out of her career? We already knew all that; no need to resort to prop comedy. Unless you are Liberace, Elton John, or Count Chocula, wearing a cape in public on any day other than October 31 means just one thing: You are a jackass. For supporting evidence, we submit the giant tattoo, oversized bling, jauntily cocked hat atop a do-rag, and omnipresent cigarette dangling from his digits. Bold move for him to start smoking all over Los Angeles, where you're not even allowed to smoke in your own home.

We suppose it could have been a stirring sense of self-awareness that prompted Federline to write his "rap" "song" entitled "America's Most Hated," but we think it was just the drugs. And we're not making that up—in the song, he insists that he's "extra-stoned" and that "the marijuana got [him] heavily sedated," to the point where he's "so high [he] could prolly drop a shit and fly." Classy! Brush your hair and lock Grandma in the shed, America, because our collective pants are about to engage in some SERIOUS self-removal!

Even when El Federleezy goes out in public wearing a sportcoat, he manages to look Federsleazy. The long ash on his well-sucked cigarette, the wrinkled pink shirt hastily (and, we suspect, improperly) buttoned, and the refusal of his undershirt to go away and leave us all alone combine to create a potent Fug cocktail. And that's without even taking into consideration the reedy facial hair, the failing soul-patch outcropping (apt in that he potentially has no soul), and his clammy, jaundiced pallor. Also, when was the last time he washed those pants? Respect the pants, man. Someone has to teach the kids that lesson, and it sure as hell won't be Britney.

Back at the height of his Mr. Spears days, even when he left the house looking objectively okay, we still found ourselves gazing upon his visage and simmering with rage. Sure, bitch crazy and all, but something about Britney still has us yearning for her to pull it together, and we're pretty sure that K-Fed (or living with K-Fed, or sex with K-Fed . . . oy, where did we leave the Pepto?) had a big hand in pushing her further down the road to Nutjobville. And even if he was ultimately just a symptom of her Crazyitis, rather than the Patient Zero we all assumed him to be, he'll always be the largest symbol of her downward spiral.

Why is K-Fed waving at the crowd at a movie premiere? He was never the one with the platinum records, the killer abs, and the starring role in *Crossroads*. There is no scenario in which people go, "Oh my God, you guys, it's K-Fed! WOOOO!" Okay, maybe if he was being introduced as the first man to be shot into the sun. But aside from that, no one is ever going to look at him and go, "My lands! That Kevin Federline is so handsome in his girlish-pink suit jacket! I shall run out and get his CD right now!" Instead, people just see this kind of behavior and turn to one another and say, "Dude, I totally hate that guy."

We totally hate that guy. So, Kevin, stop being that guy. Put him away. For good.

Paris Hilton

The Simple Life

In the past few years Paris Hilton has done the unthinkable: gone from being the inspiration for the slam "celebutante"—meaning somebody who is famous solely for running around town flaunting her hard-unearned money and dubious genetic assets, usually while drunk—to being an *actual* celebrity, with a reality show, a book, a fragrance, a range of preternaturally shiny clothes sold at celebrity shopping shrine Kitson, an album, and the requisite brief stint in prison.

This is not to say we think any of these were valuable contributions or that she achieved them due to demonstrable talents of her own. The reality show was largely successful because (a) Paris is not smart; (b) Paris is not polite; (c) the aforementioned are both gross understatements; and (d) her partner in hijinks, Nicole Richie, carried the whole thing. On the perfume tip, we are *guessing* Paris did not don a pink leopard-print lab coat and hole herself up with a chemistry set. (Although the image of her attempting to understand the periodic table never ceases to amuse.) If her singing talents are mutton, then the album dressed them up as awfully gamy lamb. And the book, *Confessions of an Heiress: A Tongue-in-Chic Peek Behind the Pose*, serves chiefly to validate Paris's existence by presenting her as a role model and pioneer for the overprivileged. She takes credit for the number of socialites who participate in fashion shows by pointing out that she was the first: "By being brave—and channeling my 'inner heiress'—I created an opportunity for other young heiresses." Just think, all those poor rich girls would never have opportunities in life without Paris Hilton. Someday she may start performing miracles. She is already adept at parting certain things.

Could this outfit be a relic from Paris's brief, vain flirtation with designing a signature line of ballroom dancing costumes? That, or she threw a fit one day that Nicky was being allowed to start her own company, and she took a scissors to one of her sister's mannequins—a disturbing bit of dummy-on-dummy crime that resulted in this shredded, shiny nightmare that's one stray snip away from showing the paparazzi the private parts that many foreign shipping heirs, rising actors, first-round draft picks, oily sons of billionaires, talent agents, studio execs, limo drivers, and bathroom attendants could probably draw from memory.

And although Halloween *is* undeniably a time when girls love to get away with dressing in naughtier-than-normal clothes because it's the one night of the year when you can do it without getting called a Hilton, Paris herself has yet to ascertain the line between "cutely risqué" and "raiding the underwear drawer."

We would suggest that she is often the cherry on top of a fug cake, were it not so wrong to use Paris's name in the same sentence as "cherry."

"Although," Bruce Vilanch would say, peeking up from the lower right corner to address Whoopi in the center square, "they both have pits!" Whoopi would fire back, "And they both come soaked in alcohol!" The studio audience would cheer, and the poor contestant would look at Tom Bergeron as if to say, "Could somebody just please answer the question?"

Unsurprisingly, Paris being Paris, she can turn even something quasi-demure into an exhibitionist exercise.

On first glance, the lacing, the ribbon, and the fact that they together make no pretense of offering coverage all combine to make one wonder if she's actually put this dress on backward. And again, Paris being Paris, she figured she'd make it impossible to miss her cleavage by propping it up in a very flimsy black bra, as if to invite eager suitors to prove their worth by gnawing through it in twenty seconds or less. If you haven't tried before, the line forms to the left, and we expect it to be rather short.

Bai Ling

*Sky Captain and
the World of Tomorrow*

Bai Ling *seems* like one of those people who are famous for being famous—for showing up places in various stages of extreme undress, for treating the camera to the occasional nip slip, and for consistently getting invited to events celebrating projects in which she had exactly no involvement whatsoever. And yet a quick glance at Bai's CV reveals that the girl works all the freaking time. So why isn't she known for all the hard work she does off the red carpet?

Outfits like this probably have something to do with it.

Yes, it does appear at first glance that she's wearing a hoodie, boots, and a belt. Period. And it is telling indeed that our first reaction to this high-class getup is not, "HOLY CRAP, SHE FORGOT HER PANTS!" but rather, "Oh, Bai Ling's not wearing pants. Hey, are we out of Diet Coke?"

Because the thing about Bai Ling is that she shows up places naked, like, pretty much all the time. There is, of course, some variation in the genres of nudity, which makes sense in that she herself has claimed—in public, to reporters—that she has anywhere from eight to nineteen different personalities living inside her. And she swears they all have opinions about her wardrobe.

One of them LOVES to wear a glittery bra top!

Note that this outfit appears to have purposely been altered so as to reveal as much sparkly undergarment as possible. Which is perhaps the point of a sparkly undergarment to begin with, but that doesn't make it right. Also, way to downplay the sex appeal aspect with a schoolgirlish beret and argyle tights, but we can totally still see your boobs, lady.

Another one of Bai's many misguided personalities appears averse to zippers, buttons, ties, or fasteners of any kind, and absolutely REFUSES to put on the sequined bra top, but only because this personality rejects any bra at all.

She only wears outfits she can step into and out of at a moment's notice. Like a superhero! Her powers include sitting down in this outfit without flashing unsightly belly fat rolls, and advanced use of boob tape.

And finally, of course, there's our personal favorite: the personality who just really, really

wants to be a French pirate wench as styled by *Hustler* magazine.

Again with the beret! Maybe she's wearing it to retain body heat, since the rest of her is completely exposed. We like to think that this personality is obsessed with *Pirates of the Caribbean* and its sequels and spends a lot of time putting on eyeliner and talking to a poster of Johnny Depp. Then, when she leaves the house, if she runs into Orlando Bloom or Keira Knightley, she totally pretends that she knows them and it completely freaks them out, which is fun for everyone.

In the long run, of course, despite their sartorial differences of opinion, all of Bai Ling's personalities have one thing in common: They love, love, love to be naked. They run from pants the way a sensible person runs from rabid wolves. They shun covering the midriff the way Mormons shun coffee. But in reinforcing, over and over again, the idea that Bai Ling = naked, Bai and all the little Bais inside her are rendering her admittedly hot bod . . . kinda boring. Therefore, we suggest that she Put It Away. At least a *little*.

Tara Reid

Josie and the Pussycats;
American Pie; Taradise

Once upon a time, Tara Reid was a cute, blond unknown starring in the gross-out surprise hit *American Pie*, a movie in which she was cast as a virginal romantic debating whether to give it up to her scrawny boyfriend. She was engaged to squeaky-clean Carson Daly of MTV, who managed several months of actually seeming in love with her before he ran for the hills, and nobody thought much about her at all except to muse in passing, "Hmm, that Tara Reid girl is sort of appealing, I guess."

Sadly, this fairy tale doesn't have a very happy ending. Tara tumbled from "relatively cute girl" to "shockingly un-self-aware bloated party animal" in the blink of a heavy-lidded eye that closed and didn't reopen until the next morning, at which point it quite possibly spied the giant pool of sick in which it found itself and closed again in the vain hope that the mess would all go away on its own. Now the twin demons of her drinking and her incessant whining about how she is more than just a boozehound—usually uttered immediately prior to the release of embarrassing photos of her flashing her "accessories" while wandering out of a hotel room unbrushed and unwashed—have completely ruined whatever career she might have had. Not to mention her body.

However, as it turns out, all the warning signs may have already been there.

Even *before* her benders became notorious, Tara was still refusing to tuck everything away in its rightful place. Tiny running shorts and a very unreliable-looking drawstring bag do not an outfit make, at least not in a normal universe where people don't *allegedly* get so drunk that they fall down every single night.

Then there were those notorious implants. And photos in which they are hanging out while her eyes refuse to focus.

Here, Tara's overtanned, oily version of party nudity makes Paris Hilton look clean and composed, especially when they have the courtesy to wear nearly the exact same garment (see page 79).

There is something very stringy about this phase of Tara Reid's sad, sodden existence. As one of us just recently said to the other when looking at the above photo, "Poor Tara Reid. Just look at her. She *is* kind of a bloated ho." When you take over the hosting duties of a partying-themed E! show called *Wild On* . . . and you completely ruin the show because you are too often wild and too rarely on, then you truly are a gigantic mess.

It's tough to say how a dress this heinous is *supposed* to flatter a bustline, much less prop it up, but certainly this display of depressing saggage isn't what the designer had in mind—unless the designer was Tara herself, with nothing but the *Dynasty* season one DVD and a penchant for any scene where Blake romances Krystle by the fire in her series of satin nightgowns.

"It would be the ultimate dream for me to win an Academy Award, be in love, and have kids," she was once quoted in *People*. Unfortunately, the only way that's likely to happen is if she sells the rights to her story to Ron Howard. He'll then get Akiva Goldsman to write a sensitive and tender script that paints Tara as a mentally troubled young girl who once tried to pay for her acting dream by baking *actual* pies but who is also a secret math genius who has been so marginalized by others that she's afraid to live as her true self. Entitled *American Pi*, it will create an immediate sensation when Tom Bosley is cast as the gruff but lovable grandfatherly neighbor whose wit and Werther's Originals were the only bright spots in her sad youth. Then Howard will refuse to allow Tara to play herself, choosing instead the dynamic duo of Ashley Olsen (as early Tara) and Mary-Kate Olsen (as latter-day Tara). Reid will be given a perfunctory producer credit and therefore won't be eligible to be onstage when Howard accepts the Oscar, yet *will* be hauled off by security when Howard thanks "the one person we couldn't have done this without: René Descartes," and Reid storms the podium and rams the award up his left nostril.

AND THE BRASS BURKA GOES TO . . .

It is only by the skin of her teeth that Tara Reid is *not* the winner. Tara was not necessarily the most obvious candidate (that honor goes to the always-20-percent-clothed Bai Ling), nor the most irritating (Paris Hilton), nor the most proud of her plastic surgery (Pamela Anderson), but she *was* the saddest case of them all. Being a party girl isn't a crime, and we love a good martini or seven just as much as the next bar crawler, but Reid has been shockingly unable to parlay her biggest talent into any kind of legacy that doesn't include derisive snorts. *Taradise* should have been a campy delight; instead, it was an after-school special trussed up as a travelogue. Plus, what she was flaunting wasn't very nice.

And yet, making an effort counts for something; the only way she could regain a semblance of respect and a résumé was by disappearing

for a while and emerging a totally new butterfly, so she (sort of) did. The October 2006 story in *Us Weekly* (in which Tara announced her implant removal and corrective liposuction, and tried to pretend she was only drinking to numb the pain) was an interesting step. And although we aren't sure we believe any of what she peddled—it's hard to make us believe she was that traumatized by her bad plastic surgery when she routinely allowed so much evidence of it to be displayed on TV and in photographs—we *are* pleased that she seems to be showering at least 70 percent of the time. Not to mention clothing herself more attractively and finally doing something about all her grievous errors of judgment, because all her incessant and passive whining predictably went nowhere. Who knows if it'll stick, or get her any jobs, but for this shining moment in time, she did *try*.

Ergo, PARIS HILTON has swept in and nicked this dubious honor from Reid's grubby mitts. Make no mistake, we don't believe Paris will *ever* put it away but we are duty-bound to entreat her to try. Sadly, Paris will never stop finding herself infinitely more fascinating and talented than anyone else does. Nor will she ever understand the need to stash herself out of sight in a dusty attic for a while, because there will never be any flickers of self-awareness in her empty head. She'll never be anything other than Paris. Which . . . snore. We'll take the assorted rises and falls of Ms. Tara Reid any day.

The Peldon Prize

5

Most

Stunning

Achievement

in Sibling Fuggery

It's well documented by people whom we trust—largely because they spend more time with microscopes than we do—that DNA is what binds us genetically to those who came before us and will come after us, and is responsible for passing down certain traits from family member to family member. At least, that's what our biology teachers tried to tell us while we were busy trying to jam our pens into the open ends of those weird jagged gas nozzles.

So you and your siblings might end up with a similar nose, variations of your grandmother's hair color, or your grandfather's cankles. And if all those things are genetic, then maybe, just maybe, so is a person's sense of style. Or lack thereof. After all, when *Sweet Valley High* heroine Elizabeth Wakefield got in a tragic motorcycle accident and woke up acting like kind of a skank, she bought all the skimpy clothes her "bad" twin sister, Jessica, generally coveted—proving that *somewhere* in her sun-kissed blond noggin, even if she went back to normal after beaning said noggin on a nightstand while making out with dreamy cad Bruce Patman, she and her twin had a common style gene.

And although *Sweet Valley High* is a generally reliable indicator of what we should expect in life, we think there are also some pretty decent real-life examples that prove blood is thicker than fashion. Our muses in this arena are, of course, the sisters Peldon: the elder, Courtney, a blond pixie with breasts that stick out as far as she is tall, and Ashley, the brunette younger sibling, who, in addition to being an actress, fancies herself a part-time perfume entrepreneur. (Yes, you read that correctly, and yes,

each offering smells like a different variety of sugary treat, the likes of which their managers probably never let them snatch from the craft services tables when they were child-acting in such gems as *Harry and the Hendersons*.) Courtney and Ashley have become the poster children for double acts of fashion terror by showing up at red-carpet events *ad nauseum*—despite being largely unknown to anyone outside their family circle—wearing everything from sweaters adorned with sequined pineapples to lingerie to knee-length pleather bike shorts. They are a loopy delight, a glut of bad taste that so thoroughly embodies the spirit of this award that we actually created it while surfing their perfume blog and wondering if it would be inappropriate to order a scent called the Child Star.

While five other familial bonds of fuggery certainly qualify to join the Peldons in the pantheon of poor judgment, only one pairing can take home the coveted statuette.

Aaron and Nick Carter

House of Carters, singers

In 2000, Backstreet Boys singer Nick Carter was named one of *People* magazine's Fifty Most Beautiful People.

It's been a long, hard road since then. Carter, once a blond heartthrob in a boy band, endured allegations that his mother beat up his father with a remote control; a longish (for her) relationship with Paris Hilton, after which she later made completely unproven claims that he used to beat her; a "Paris" tattoo that he had to cover with a skull and crossbones and the phrase "Old Habits Die Hard"; the claims of desperately kooky Put It Away nominee Bai Ling that they were in love and engaged to be married, despite their not having demonstrably dated or even been seen together; his brother, Aaron, filing for emancipation from their parents after alleging that their mother stole money from him; a failed Backstreet reunion; and a dead-on-arrival acting career. And that doesn't cover all of it—certainly not whatever he might've had to bleach off his private parts after that aforementioned Hilton entanglement.

So it's no wonder he turned to reality TV to rake in some attention, and of course it's understandable that he might have grown into something a bit more smarmy and bloated than his lauded 2000 self.

The white suit is . . . fine . . . but the untucked black shirt underneath it plunges the entire look into the depths of loungewear, almost as if he's auditioning for *Leisure Suit Larry: The Movie*. And, sadly, the time he did not spend making his shirt and suit more presentable was apparently not applied to coaching his brother out of his slovenly slump. Aaron needs to shave the Brillo pad off his chin and consider laundering his T-shirt. We know this was taken while the brothers were living in a house of dysfunction with a whole horde of their siblings, with all the hilarious and dramatic shenanigans being captured by MTV's cameras, but surely *one* of them knew how to shut his cakehole for a second and operate a washing machine.

The Carters spend a fair bit of time schlubbing around in this manner. And we do mean in this *exact* manner—the very day after the previous photo was taken, both boys showed up somewhere else in the same clothes.

Although Nick looks mildly better for it despite ostensibly not having changed his shirt or even possibly gone home at all, Aaron still looks like a ratty little punk. And it makes them both come off like icky, lazy asshats. We're getting a mysterious itch on our sternums just thinking about it. Perhaps when both brothers churn out those change-of-direction solo albums we've been promised—Nick, a rocker! Aaron, a hip-hop god (watch out, Eminem)!—they can scrape together enough scratch to buy the younger ragamuffin a second shirt. Perhaps even one that doesn't look as if it smells like a stale bathroom.

Jason and Brandon Davis

Heirs to the Davis fortune, men about town

Well do we remember and long for the time when we knew nothing of the brothers Davis. Those were halcyon days indeed. Oh, how we frolicked and gamboled, so innocent, never dreaming that one day a suspiciously greasy man-socialite would unleash a stream of on-camera obscenities directed in a bizarrely specific way toward the details of Lindsay Lohan's bathing suit area—something he oh-so-tastefully deemed her "firecrotch." (The rest of his remarks are too ungentlemanly for us to repeat in this publication. Suffice it to say, he discussed in great minutiae what we believe are completely fabricated details of her personal coloring, odor, and physical structure. It was inappropriate in the extreme, even to a couple of nasty bitches like us.)

And that, of course, is what Brandon Davis is most famous for: being unemployed; dating a stream of more-famous women, including Mischa Barton; hanging out with Paris Hilton; and embarrassing his grandmother—wealthy philanthropist Barbara Davis, who has devoted most of her adult life to raising money for juvenile diabetes—by drunkenly (we assume) yelling about a starlet's lady parts into a television camera and then accusing her of being "poor" because she only has "about seven million dollars." He has what we'll generously term a lack of perspective.

On top of all that, you'd think he could actually man up enough to look decent as he stumbles around town insulting people's pubic hair, but no.

Let's acknowledge how massively greasy he appears. Brandon Davis ALWAYS looks like he used extra-virgin olive oil for shower gel and Crisco for pomade.

Look at him here with Mischa, back when he was lucky enough to get her to touch him:

Did he bike to this event? Was this picture snapped right after he did a set of wind sprints? Is he running a fever? Why is he dressed like a Las Vegas Johnny Cash impersonator? Also: Close your piehole, mouth-breather.

And as if Brandon Davis and his slur-slinging, sweat-dripping self aren't nasty enough on their own, he occasionally appears in public with his brother, Jason. Now, Jason's never spoken out publicly about any starlet's personal hygiene. He seems to have a working relationship with soap. He may be the sweet, lovable lug of the Davis family. We'll never know, because he appears to be sharp enough to keep his mouth shut, unlike his wastrel sibling. We do know, however, that he has an equally questionable eye for fashion.

This may, in fact, be the exact moment that Mischa Barton decided she had to extract herself from the clutches of the Davises.

Listen, we don't care that Jason's got a little extra Davis to love. He's probably cuddly, and we do like to cuddle. However, it's a good rule of thumb that if you're carrying a few extra el bees, you should probably avoid white satin.

On the other hand, adding a little Elvis to your look isn't the worst thing you could do.

This is.

We'd give them a pass for this photo being snapped on Halloween, but . . . we don't like them, so we won't.

Mary-Kate and Ashley Olsen

Actresses, designers, the world's most famous twins

The Olsen twins have a tendency to look like two teeny little homeless girls when they're out on the town.

In this picture, it's easy to imagine that Mary-Kate's cup holds not coffee, but spare change from compassionate strangers. And while we certainly identify with just throwing on whatever to run out and grab a bite, we try to exclude items in the bag for the Salvation Army.

On the other hand, at least they look sort of happy when they're running around in shorts stolen from the Los Angeles Lakers' laundry room.

Here, you'd think someone had just strangled their dog. Look alive, ladies: It's MTV, not the electric chair. Also, tablecloths are to be worn only if you have four legs. EACH.

Maybe the girls look sad because they realized that by doing the matchy-matchy

twinsie thing, neither one is wearing what she *wants* to wear. In general, at red-carpet events and when left to her own devices, Ashley Olsen manages to look unusual but chic, while Mary-Kate often looks like a scary doll who will come alive at night and freak you out by spending several hours stroking your hair while you wonder if she's going to slit your throat.

Here again, Ashley's dress is hot, but Mary-Kate looks like a Bavarian zombie. She's really sorry—you seem supernice—but she needs to eat your face now. Then she's going to crawl back into her crypt and leave you alone. And faceless.

We understand that being part of a famous pair since birth must make for a difficult young-adulthood, especially for girls who've had to deal with sleazebuckets who counted down the days until they were old enough to be pursued outside the pesky confines of that whole statutory-rape law. We therefore understand why the girls would react to that kind of weirdo scrutiny by going out wrapped in clothes that the rest of us would have consigned to the rag bag months ago. So, you know, we get why they're going through a ragamuffin period. But there's a lot of acreage between "I'm Not My Sister, and I'm Not a Sexpot, So Stop Objectifying Me, You PERV" and "Evil Madame Alexander Doll."

Maybe Ashley can help her sister find some of it, because we can't deal with this kind of thing anymore.

Please don't place a hex on us, Bellatrix Lestrange. Look in the mirror—if, in fact, you CAN. You're dressing like that goth girl we went to high school with, who spent all her time ditching class and smoking cloves behind the ceramics building and moaning about how no one really understands her PAIN (except maybe Morrissey), before making a Taco Bell run in the Lexus her daddy bought her. No one wants to be that girl; you're no exception.

Paris and Nicky Hilton

Socialites, dilettantes

If there were any justice in the world, Jason and Brandon Davis would be the most repugnant siblings in this category. It doesn't seem right that there could be another pair even *more* tacky and gross and representative of, you know, the world's gradual descent into complete tacky grossitude.

Like the Davis boys, the Hilton sisters are composed of one lesser-known, generally inoffensive individual, and one considerably more famous, often totally offensive celebutard sibling who drags the other down into the mire time and again. Between Nicky and Paris, we've got: two DUIs (Paris); driving with a suspended license (Paris); a stint in the joint (Paris); a sex tape (Paris); one famous feud with the other person on her reality show, now allegedly patched up (Paris); yet another celebrity-themed perfume (Paris); a CD including a song featuring the poignant and poetic lyrics "I'm hot to death/and I'm so, so, so sex-ee" (Paris); at least two broken engagements (Paris); one hacked Sidekick, the contents of which leaked onto the Internet, giving every Billy Bob with DSL the ability to call Jay-Z to ask if his refrigerator's running (Paris); an embarrassing display in which she egged on Brandon Davis's "Firecrotch" aria (Paris); a couple of minor/medium car accidents (Paris); a quickie Las Vegas wedding and swifter annulment (THERE you are, Nicky, FINALLY—way to go); and a bunch of other stuff we've blocked out because we need to save some room in our brains to remember the details of every episode of *90210*. In essence, if Paris Hilton were *our* sister, we'd join the Peace Corps and donate our nonessential organs to the sick, just to readjust the balance of good and evil in the universe.

Instead of heading out to Darfur or whatever, though, Nicky Hilton sort of just tags along with Paris, generally looking like she's there to give Paris a ride to the next event, rather than actually being invited to whatever it is herself.

Here, for example, Paris appears to be attending the AVN Awards, where she is probably nominated for something like Celebutante-Turned-Porn-Star Most Likely to Cause Her Forebears to Roll Over in Their Graves and Refuse to Allow Her to Stay in the Hotels That Bear Their Name. Nicky is just there to drop her off, as you can tell from her casual outfit and chauffeur's cap.

Here's another instance in which Paris appears to be attending some fancy-schmancy party, while Nicky has just popped in to say hi before running down to the country club pool for hot dogs and lemonade with the kids.

How can they possibly be attending the same function? Paris is wearing a gown, whereas Nicky is sporting shorts. Neither of them looks bad, per se (we hate formal shorts, but let's not get into that right this second), but either one of them is seriously inappropriately dressed, or they both are. These girls are together all the time. Clearly they talk often—did they not discuss what they would be wearing on this occasion? Was there no conversation in which one of them said she would be wearing a floor-length gown, and the other said she would be wearing shorts, and then someone said something like, "Wait, what?"

Apparently not: Yet again, Paris is in a gown, and Nicky is wearing something that she probably picked up at Forever 21 on her way home from yoga. In a way, we admire her for schlumping around like the rest of us girls who aren't heirs to a fabajillion-dollar fortune. But on the other hand, we don't understand why she doesn't take a couple of those fabajillions and buy herself something nice.

Jessica and Ashlee Simpson

Singers, reality TV personalities, and "actresses"
(*Dukes of Hazzard* and *7th Heaven*, respectively)

Dear Jann Planders,

I've been a fan of you and your advice column ever since I was a little girl and you were, like, seventy-five. And now I need your help. I'm in *agony* here. Do you know what it's LIKE to have a sister who does, like, *exactly* what you do? Except totally not as WELL, but people start to like her for it anyway and all of a sudden she's all grabby with your stuff, trying to fill your hand-me-down shoes even though you haven't even decided to hand them down yet and even if you did you might want to have the option of giving them to somebody NEEDY or POOR who doesn't HAVE things like designer clothes and custom-made hair and might NEED a nice pair of my old shoes, so DON'T STICK YOUR NEW NOSE all up in my BUSINESS?

Do you? Do you know? Because it's driving me CRAZY.

It used to be so GOOD, Jann. Everything was the way it should be: America totally adored me because of that whole Chicken of the Sea thingy (but seriously, who knew?), I had a hot husband who needed me because my career was so awesome, I could get away with falling asleep on my pink highlighter and waking up to find that it had bled all into my hair and yet STILL going out in public and having people love me, and my SISTER—let's call her "Ashley"—was this total tomboy who wore lumberjack plaid and racecar shirts and all kinds of other things that looked like she picked them up off the floor of her seventh-grade boyfriend's bedroom. I mean, seriously, would YOU have looked at her, or at me? The answer is ME.

And then "Ashley" kind of got a music career going and decided to try to dress like a girl, and that fully bugged me, Jann, because *I'm* the sexpot in the family. Daddy said so. So anyway, I kind of told "Ashley" that she looked good in that weird ruffled shroud even though it was too tight and made her look like a lounge act from, like, 1984 or something, AND I even told her that her hair looked totally wicked in that ponytail with all the little elastics around it. But, see, Jann, that girl is DIABOLICAL. Because SHE told ME that I looked really ladylike and romantic in my outfit, but she is a LIAR, because the second I got there some singer I don't like who we'll call Britney Spears pointed at my formal shorts and LAUGHED AT ME and then asked who I'd paid to rip my shirt, staple a hanky to my boobs, and paint me orange. Well, I was OUTRAGED, Jann. Because you know what? I think that little twit "Ashley" was totally DELIBERATELY misleading me so that she'd look better! What kind of sister DOES THAT?

Now my sister's all sleek and doing musical theater and she's Daddy's Best Girl and I'm stuck wearing a tunic my mother ordered from a *Dynasty* tribute line on QVC that's designed by someone who used to be Linda Evans's neighbor's Avon lady while "Ashley" gets the little lacy getup and the REVIEWS and the ATTENTION and the NOSE and the whole thing makes me want to throw up all over her little jazz shoes. Because you know what I get to do now, Jann? DO YOU?

I get to dress like a freaking FARM GIRL while I hold giant Blockbuster cards. Can I win a Tony for that? Do I get flowers and cheers? Do I get a free crate *of* Cheer? NO. I just get a lifetime supply of Sno-Caps and free rentals, which means I'm stuck watching *Dukes of Hazzard* and *Employee of the Month* while "Ashley" is out there NOT holding giant envelopes and staring at her failures on DVD. Well, not until she comes home and finds that I'm "accidentally" watching the *Saturday Night Live* where she got busted for lip-synching.

I'm fairly sure these rage issues aren't helping my complexion. My hairgay thinks it's giving me scalp wrinkles.

So, Jann, I'm a mess. I need your guidance. (You're *way* better than that cow Dear Gabby. I hope you know that.) It's important that you write back, because I am seriously THIS CLOSE to funding a revival of *Li'l Abner* on Broadway just so I can totally outshine her Roxie with my versatility as Daisy Mae. God, I even already have the cutoffs from when I was Daisy Duke. Another Daisy! It's DESTINY. Right? It is, right?

Kisses,
Yellow Rose of Texas

AND THE PELDON PRIZE
GOES TO . . .

Look, for all we know, Jason Davis is an absolute peach, a cuddly teddy bear of an angel who builds puppies out of snowflakes and sparkle dust. Unfortunately for Jason, though, it doesn't matter, because of his shared DNA with his nasty brother.

All the nominees put up a serious fight. But none of these pairings dwell as low as the Davises, because no sibling is dragging down the other half of the duo quite as far as Brandon is. He is loathsome, and for that, THE DAVIS BROTHERS win this year's Peldon Prize.

We're sure this is just the beginning of a long, putrescent winning streak.

The Errstyle

Most

Vexing

Coiffure

Catastrophes

While the Fug Awards have thus far focused mostly on clothing missteps and mistakes, if you look like you styled your hair with an immersion blender, no one is going to be admiring your outfit. Hair counts. And sometimes, it counts against you.

Tyra Banks

America's Next Top Model, The Tyra Banks Show

Former supermodel, current talk show host, shaper of young lives and self-esteem problems, and wannabe soothsayer Tyra Banks has amused us endlessly with her cavalcade of ridiculous weaves. Yes, "weaves": Despite hitting the town toting an exposed expanse of lumpy wig tape as her plus-one, Banks still insists she's the queen of the hair weave, so we'll go along with the act even though we find it more than a tad . . . wait for it . . . *unbeweavable.*

And besides, we don't care. Wig, weave, or dead animal perched upon her scalp, it matters not. Because whichever it is, it doesn't change the fact that she pays a lot of money for her hair, which is why her genius in this arena cannot be ignored: costumey, campy, dragalicious—styles so terrible they're actually triumphant.

Only Tyra could be standing still at a microphone while sporting hair that looks like it's in motion—specifically, trying to run far, far away, and fast. It almost appears to be caught in a very small, localized hurricane.

Check out the hair she sported throughout the entire seventh season of *America's Next Top Model.*

Besides the fact that her hairline appears matted and glued down, the damn thing is lopsided. It's almost impossible to look at this without your head listing to one side.

Her other interpretations of red-carpet glamour are often equally disturbing. Sure, it's *tempting* to slap on a bejeweled choker, plump up the basketballs, and shake out the old Dee Snider fright wig, but not since Christina Aguilera's di*rrr*ty phase has anyone knocked loose the screws required to actually *do* it.

It's equally compelling to whip out the ol' crimping iron, invite our best girlfriends over, suck on tomatoes and chug cranberry juice, and do one anothers' hair while we dream of our upcoming nuptials to Dracula.

And yet we have to admit we'd be bereft without Ms. Banks's bizarre hair hanks. Nothing brings a smile to our faces quite like these delicious little cake toppers. We are, in fact, hoping her talk show devolves (although, actually, it might be an evolution) into episode after episode of her slapping crazy weaves and wigs on every last guest. If Tyra's so hell-bent on putting her stamp on the world, she might as well go all out with what she does worst—which, conveniently, is also what she does best.

Tom Cruise

Top Gun, Mission: Impossible, War of the Worlds, High Priest of Scientology

There's a lot we'd like to say about the turn Tom Cruise's life has taken since *Top Gun* came out and we spent a year kissing his poster every night before we went to bed. Unfortunately we're too scared of the Scientologists to say any of it. So we're not going to talk about any of that: not the couch-jumping, nor his insistence that we refer to Joey Potter as Kate, nor the chatter that his child looks a lot like Chris Klein (hey, maybe Joey has a TYPE, okay?), nor how he got dumped by Paramount, nor how he knows the history of psychology despite being an actor rather than a historian or a psychologist, nor thetans and Xenu, nor any of it. We imagine the Scientologists are lovely people, and we're happy for them and we think that if Tom Cruise wants to run around berating women suffering from postpartum depression, he is certainly entitled to do so. After all, what better way to appeal to your hugely female fan base than by telling those ladies their feelings are all in their heads and that maybe they should take some vitamins? It makes a lot of sense to us, and we wish him nothing but the best.

However, we have noticed that his relationship with Katie—sorry, KATE—Holmes has coincided with a distinct downturn in the quality of his hairdos. It's safe to say that we all became accustomed to the Tom Cruise of yore, he of the dashing, cropped hair and the rakish sunglasses. And

yet, once his child-bride-fueled euphoria set in, this is what we got:

What's with the bangs, Tom? Because, confidentially, if you're trying to make people—not us; *other* people—stop saying things about you like, "He's gone kind of crazy, don't you think?" and, "I can't even watch *Top Gun* anymore because I keep thinking about him jumping on that sofa," it's not a great idea to prance around town in bangs that your mommy cut with pinking shears, a Weed Eater, and her manicure

scissors, respectively. Excessive man-bangs rarely inspire confidence, unless you are a Beatle, and then the only confidence they inspire is that we're about to hear a masterful pop song. They certainly don't say, "I'm the biggest movie star in the world," "Please pay me twenty million dollars a picture," or even, "I am a committed heterosexual." Instead they wail, "Why can't I seem to keep a stylist on my payroll?"

Listen: Bangs are not for manly men, and if there's anything that Tom Cruise has built his career on, it's playing a Manly Man Who Saves the World from Things Blowing Up. Bangs require too much upkeep. No man saves the world in bangs. Bruce Willis would never star in *Die Hard with Bangs*. That's ridiculous. Can you see Indiana Jones with bangs? He doesn't even wash his hair—that's what the hat is for. Would Clint Eastwood ever have bangs, for Pete's sake? No. Bangs are for girls and cute boy musicians, not for men who shoot people and/or prevent people from shooting people, or actors who make a living shooting people and/or preventing the shooting of people. Frankly, a mustache would be more advisable.

Vincent Gallo

Buffalo '66, The Brown Bunny

By all printed accounts, it appears Vincent Gallo loves himself. He's been quoted as saying he stopped painting in 1990 just to rob the undeserving world of his artistry. Gallo's own home page features a Q&A in which he announces, "The best interview of Vincent Gallo was done by Vincent Gallo. The best articles about Vincent Gallo were written by Vincent Gallo, the best acting performance of Vincent Gallo was directed and edited by Vincent Gallo from a screenplay written by Vincent Gallo, even the best photographs of Vincent Gallo were taken by Vincent Gallo." And, of course, he wrote and directed a movie, *The Brown Bunny*, that required actress Chloë Sevigny—whom he once called on his site the "boring Connecticut girlfriend" of director Harmony Korine—to give him an on-screen blow job, as if the greatest present he can give to an overprivileged starlet from Snoresville is the gift of his engorged wang. Further, when critic Roger Ebert dared to criticize the movie, Gallo in turn reportedly called him "a fat pig with the physique of a slave trader" and put a pox on Ebert's colon. In short, our hero is so enamored of his vision that he can't handle being told he's actually repellent.

Well, strap in, Vincent, because it's going to be a long ride.

We can't understand how someone with such endless self-affection could possibly go out in public with the matted, mottled hair and haggard complexion of a dying vagrant. If an empty plastic beer cup from a fraternity kegger—sticky from a waterfall of urine and residue from being used as a spittoon and found discarded atop a broken condom—could take human form, it would resemble this picture of Vincent Gallo. It's everyone's worst night from college, crowned by week-old bedhead.

This handlebar mustache and ratty attempt at muttonchops are no improvement on the wispy, unwashed disaster he previously sported. News flash, greasehog: Dressing as if you're of the *Deadwood* era does not mean you can adhere to the Wild West's more primitive standards of hygiene. And in this patchy side view it just looks like somebody screwed up when seeding the lawn.

Here, Barbara Bush appears terrified she'll catch something and strives to turn away from him while he sulks petulantly—and poorly coiffed—in his seat.

But buck up, Vincent. You know full well that your sense of self-worth and shortsighted belief in your own charms will save any of this—our slings and arrows, Barbara's fear—from hurting your feelings in a lasting way. Just try to remember this much: If you *are* going to chin up, please do it in the direction of a running showerhead.

Kelly Osbourne

The Osbournes

During the height of the popularity of *The Osbournes*, the somewhat ground-breaking MTV reality show that paved the way for such delights as *House of Carters*, *Hogan Knows Best*, and *Growing Up Gotti*, Kelly Osbourne took a lot of heat from people for a number of things: being chubby, being bratty, and being drunk when underage. As for us, we don't fault her for any of those things. Who hasn't been chubby, bratty, or drunk when underage at some point in her past? We kind of dig Kelly for being quirky and difficult and flawed. But we are also getting a little older, and sometimes our reaction is not so much, "ROCK! Purple HAIR!" as much as it is, "You'd be so pretty if you got that hair out of your face." And Kelly Osbourne is the Miss Teen USA of Needing to Get That Hair Out of Your Face.

Here's the deal: (a) We can't see your pretty eyes, and (b) HOW CAN YOU EVEN SEE? Seriously, how is she walking around like this without bumping into things? We watched *The Osbournes*. The girl is not a gazelle. Neither are we, so all three of us need to use our eyes to maneuver our bodies around without breaking bones. Also, a bowl cut isn't flattering to anyone. Not even to bowls.

We're a little bit scared that the back of her head might be totally shaved here. In fact, we're kind of relieved that we can't see it, because from the front it looks like some kind of Davy Crockett coonskin cap . . . except made of HER OWN HAIR.

Waah! Maybe you'd be happier if you weren't sporting the latest from Cruella de Vil's House of Weaves.

We respect fake hair. Fake hair is fun! And this at least has a kind of Sydney Bristow–esque kick to it. But Kelly is not a spy for the CIA (that we know of), nor a drag queen, nor attending a rave, nor taking over as the lead singer of Deee-Lite, nor auditioning for the role of Strawberry Shortcake. She just kinda looks like she's trying too hard, which is not rock'n'roll AT ALL.

Sharon Stone

Basic Instinct, Basic Instinct 2, Total Recall

Sharon Stone is many things: humanitarian, brain aneurysm survivor, mother of three, ex-wife of a heartily mustachioed man who was bitten by a Komodo dragon, actress, and owner of one of mainstream film's most documented vaginas.

What you did not know is that Sharon Stone is *also*:

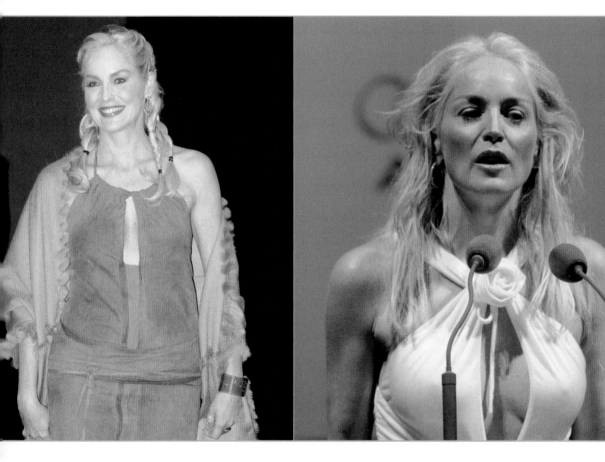

(a) A quaint farm girl anxious to prove to everyone at the square-dancing competition that she's still "got it";

(b) A thrill-seeking public speaker who arrives at all her engagements via hang glider;

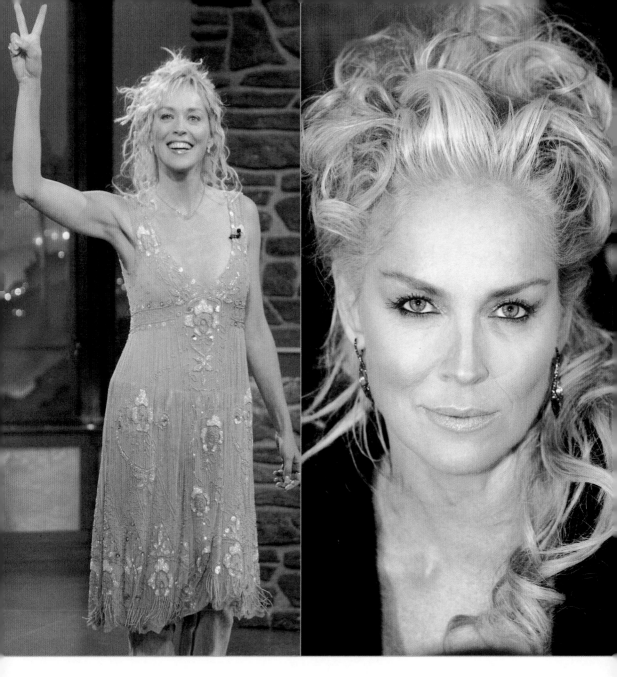

(c) A benevolent yet bizarrely self-destructive advocate of global harmony, with a compulsion for jamming that omnipresent peace sign into every nearby light socket because her dojo keeps telling her to "find her power";

(d) A kook whose psychic told her she will be reborn in 3013 as Queen Amaryllis of Planet Icyfrost.

AND THE ERRSTYLE
GOES TO . . .

We're scared of Tom Cruise's legal team, Kelly Osbourne is just a crazy kid, and we don't want to talk about Vincent Gallo anymore. And so the Errstyle goes to SHARON STONE, by a . . . hair (sorry). Yes, yes, we know. Tyra Banks *seems* like a slam dunk, but think about it: Can you imagine Tyra Banks *without* her giant, crazy wigs attempting to leap off her head and eat your face? Like Samson, without her big hair Tyra would be but a weak imitation of herself. Tyra IS bad hair. We would never want to strip her of that which so defines her. In fact, we'd like her to continue to model larger and more elaborate hairpieces until she looks like a time traveler come to bring us news from the court of Louis XVI.

Whereas Tyra has built her empire on weaves and wigs, Stone has built hers on being classically glamorous, as in the photo here. So Tyra's bad hair fills us with glee, but Sharon's just makes us sad.

The Tanorexia Award

Orange

You Sorry

You Paid for

That?

Many moons ago it was considered the height of chic to be as pale as the day you emerged screaming from the womb. Remember Elizabeth I and her crazy lead-paint white face? Or all those pale heroines of Victorian novels who eventually died of consumption, but not before teaching some devilish cad about the power of purity and true love? Eventually, of course, the fad headed in the other direction: Being tan meant that you had enough free time to sprawl on the beach covered in oil and burn yourself like toast, rather than being chained up in the Xerox room.

Now, you would think that once we all found out that searing yourself like a chicken breast on a hot grill makes you look old and wrinkly and gives you cancer, the pendulum would have swung back the other way. And for many of us, of course, it has. But for a certain subset of the celebrity population, this whole skin cancer thing has inadvertently led to another painful, tragic—albeit totally less fatal—condition: tanorexia.

A tanorexic begins using self-tanner in an attempt to look less pasty but eventually loses all sense of perspective and entirely forgets what human skin actually looks like. The subject then applies more and more and more until he or she begins to resemble a traffic cone.

Tanorexia affects men and women, young and old, and it must be stopped before our youth begin to believe that people are supposed to be the color of a catcher's mitt. And so we shine our UV light on some of Hollywood's most overly tanned offenders, eventually crowning one poor orange fool the tannest of them all.

Katie Couric

Today show, *CBS Evening News with Katie Couric*

When Katie Couric burst onto the break-of-dawn chat-show scene in the early nineties, America was entranced by her perky demeanor and shiny, well-waxed legs. Or so we've read. Back then we were too busy worrying about what to wear to the prom and wondering whether we would ever get to meet Dylan McKay—and oh my GOD what if it was on a bad hair day!—to bother watching the *Today* show or really anything that had the gall to air before nightfall.

But look how winsome and pale she was back then!

As the years rolled by, she got a little tanner:

"Why, yes, you CAN trust me," she's saying here. "I'm like your Girl Scout leader, your kindergarten teacher, and the president of the local chapter of True Love Waits all rolled into one! Don't leave the house without your SPF 35!"

But just in a healthy way. An "I just golfed eighteen holes and then took my kids to get ice cream before doing my rounds for Meals on Wheels with the sunroof open" kind of way. And then things began to take a dark turn.

Katie apparently decided if a little tan was good, a whole heck of a lot of tan was better, because the next thing you knew, we were at DEFTAN 1:

Somehow she went from "lightly burnished" to "dipped in batter and deep-fried." Even Clay Aiken looks scared, and he spent several weeks getting up close and personal with Paula Abdul. (His slightly shell-shocked expression may also have something to do with Katie's unfortunately high-waisted, loose-crotched white trousers.) There's something wrong when a woman who's positioning herself as someone whom America trusts for all its news—and news-esque chatty celebrity interviews!—feels that she

would be better off if she looked more like America's *other* most-trusted people: the lifeguards from *Baywatch*.

After this phase in Katie's epidermal journey, we began to wonder: Where would she go from here? Could she get any oranger without actually transforming into a piece of fruit? Fortunately, we never had to find out the answer, because—just in time for her gig hosting *CBS Evening News*, where being beige in person and demeanor is preferable, if not required—La Couric blessedly downgraded herself from the Human Orange to Ms. Monochromatic. We like to imagine this was preceded by a week of hearty denials that dissolved into a dramatic crying jag as she stared at herself in the mirror, realizing that she accidentally transformed herself into something best suited for a Julius.

Still, from trauma came something infinitely better: actual *flesh*-toned flesh.

Lucy Davis

The Office (BBC), *Shaun of the Dead*, *Studio 60 on the Sunset Strip*

Almost more vexing than the habitual day-to-day Oompa-Loompas are the people who don a fresh coat of paint solely for special occasions, thereby deliberately pumping up the spotlight on this particular style choice. That basically leaves almost no room for error. Yet, unfortunately for the utterly cute British actress Lucy Davis, she has taken that sliver of real estate and built a mansion on it.

We like her when she's fresh-faced.

She, however, apparently prefers to look like a Reese Sticks wrapper.

Imagine you snuck into your sister's bathroom when you were nine and found a tube of self-tanner sitting there amid all her products. Curious, you smeared some on your hand without permission, because anything she had was automatically cool; a day later, the back of your hand was orange, almost as if you'd colored on it with a highlighter. "DID STEAL MY SELF-TANNER?" your sister asked, frowning. Somehow sensing she was miffed, you simply said, "Why, no," tightening your lips into what you hoped was an innocent, nothing-to-see-here smile. Now, if we had any personal knowledge of that sort of incident—and we are admitting to nothing—we would apply it to the expression on Lucy Davis's face here and conclude that she's trying to pretend everything is fine, despite being well aware that no zombie movie is as scary as the fact that she's standing on that carpet looking the color of Halloween.

Think that was an isolated incident? Think again.

It really *is* no coincidence that Lucy's father is a comedian named Jasper Carrott. (True story.) She not only repeated the bronzing, but she did it to blotchy, disheartening effect, and she fried her hair so badly that it only enhanced her crispy, stick-a-fork-in-her doneness.

Most tragically, that omnipresent uncomfortable expression exposes that she *knows* she waited too late to get the Mystic Tan and then overcompensated with three sessions too many. Such blatant failure to learn anything from her last alarming dalliance with the dreaded Special-Occasion Spritz is one of the official hallmarks of someone in a particularly vicious phase of her tanorexia. We can only pray that Lucy's loved ones—Mr. Carrott, perhaps?—will carefront her with a mirror and some exfoliant.

Lizzie Grubman

PR representative, people-mower

You may remember July 7 as Michelle Kwan's birthday, or perhaps as the date the contiguous U.S. decided it needed some delicious tropical flavor and annexed the Hawaiian islands. But for PR rep Lizzie Grubman, July 7, 2001, is the date on which she went out in the Hamptons to get an early start celebrating the anniversary of the signing of the Straits Convention of 1841—you know, the one with that old tributary bar shanty: "Three cheers for a peaceful Bosporus, three cheers for a placid Dardanelles; I drink twice as much for those long-lost ports since the day the Ottoman Empire fell"—and, trapped in the fog of her own enthusiasm for history, hopped in her SUV and plowed backward into a crowd of sixteen clubgoers, whose simultaneous attempts at celebrating the end of British rule in the Solomon Islands were thereby cruelly cut short.

Up to that point, this bleach-blond strumpet of spin was known almost exclusively in celebrity and New York social circles. That incident, though, is how Lizzie nestled into the warm nooks and crannies of the rest of America's popular consciousness. Well, for a little while, anyway.

And in a file photo circa 2001, this is what we saw: a girl with careless roots, manly brows, and skin clammy with beer sweat, who worked with celebrities but didn't care if she was one herself. Indeed, to 99 percent of the country, PR reps are faceless names in the pages of *In Touch* magazine, put into the limelight only long enough to deny that their clients are married, cracked out, pregnant, secretly hooking, dating Jessica Simpson, or all of the above. That all changed for Lizzie once she hit the people and, subsequently, the pokey. A little stint in the slammer, some sobbing, some trembling, and time off for good behavior . . . They're all the makings of a first-rate sympathy story. Nothing ups your profile like painting yourself as a repentant, wounded jailbird-angel.

Or sometimes, like painting yourself, full stop. Because as Lizzie made the rounds after her imprisonment—which included a short-lived and painfully boneheaded reality show called *PoweR Grrls* and trying to diet herself into oblivion—she went from a normal-colored behind-the-scenes social butterfly to a burnished bastion of artifice.

We're comforted by the fact that her bizarro skunk black roots are still as much in evidence as ever, suggesting that she's still the same old girl who represented Britney back when she was gorgeous. Yet, as you can see, you could play Lizzie's sternum like a xylophone; more discomfiting is the fact that she's completely redecorated herself in shades of burnt orange that manage to be age-defining, not age-defying. We wouldn't be at all surprised if an animal mistook her for a chew toy.

You'd think someone who made a living peddling fakery wouldn't be so easily suckered into the habits of the people she represents, but, alas, Lizzie Grubman has gone from fleeing the scene of one crime to ushering in the scene of another.

Jay Manuel

America's Next Top Model

Full confession time: We're secretly fond of Jay Manuel, official art director of *America's Next Top Model*'s photo shoots and unofficial wrangler of wannabe models. As the seasons have progressed, he's gotten increasingly aggravated with the cast members and occasionally veers toward being maybe, mildly, a little bit short-tempered with them. In that sense, he mirrors audience reaction, and we like that about him.

Over the years, Jay has been accused by multiple sources of being addicted to the sweet, heady fumes of spray-on bronzer. *Is* he as overtanned as the naysayers claim? Let's go to the film.

Here at GFY Awards Central, we don't particularly like to admit when we don't know something for sure, but here goes: Either Jay Manuel is EXTREMELY METICULOUS when it comes to his bronzer application (very possible), or he's not fake-tanning.

Bear with us, here. He is undeniably orange-tinged, which automatically qualifies him for this award. But we suspect that the real reason Jay Manuel looks like he's been nipping into the ManTan is that he's suffering from another, equally tragic addiction: bleachilemia of the teeth and hair.

His overly whitened teeth and blond spikes merely make it *appear* as though he's been the number one VIP customer at Sunless Tanning in the Valley for five years running. When, in fact, his coloring might just be totally normal, exacerbated by his other sad affliction but not necessarily reflective of true tanorexia.

So while Jay Manuel would certainly be a shoo-in if this award celebrated the newly held concept that one's teeth should be whiter than the whites of one's eyes, or if we were giving away something called the Q-Tip in honor of the celebrity with the phoniest blond hair, we are not entirely sure he's hooked enough on pigment to run home with this PARTICULAR prize.

Although, we must admit that after looking at these photos, we had a bizarre craving for a tequila sunrise or seven. That's *got* to mean something, right?

Nancy O'Dell

Access Hollywood

NANCY: HI! I'M NANCY O'DELL!!! AND WE'RE AT THE EMMY AWARDS!!!!
HERE WITH ME IS "FRIEND" JENNIFER ANISTON!!

PRODUCER: Cut for a second . . . That's great, you look great, guys. Killer smile, Nance.
Just . . . Jennifer, you look a little taken aback, so if we could do it again with a little bit less,
well, fear, then that would be delicious. Ready? In 5 . . . 4 . . . 3 . . . 2 . . .

NANCY: HI! IT'S THE EMMY AWARDS!! AND WE'RE HERE! AT THE EMMYS!!

PRODUCER: Cut! Okay, Jennifer, your makeup is starting to cake in that forehead furrow.

JENNIFER: I'm sorry, I know, I'll try to be better. It's just . . . seriously, she's the most frightening thing I've ever seen, and, don't forget, I've seen that guy from the Counting Crows naked.

PRODUCER: And you're a hero for it, Jennifer. Let's go again!

NANCY: EMMYS! EXCITEMENT! JENNIFER TANISTON!

PRODUCER: That's "Aniston," pet.

JENNIFER: Are you really not seeing this? I'm no stranger to bronzer, but she makes me look like I've been in prison for ten years. Did she mean to turn herself into a football?

NANCY: MY SPRAY-ON TAN IS AMAZING TONIGHT AT THE EMMY AWARDS GLOBES WITH JENNIFER ANISTON!

PRODUCER: Okay, Nancy, we weren't actually rolling, there. Hold those horses!

JENNIFER: That skin makes her look possessed. If I look at her any longer, I won't be able to sleep at night.

PRODUCER: Well, Jennifer, it's a competitive industry here in the exciting world of syndicated televised entertainment news/gossip, or STVENG, as we like to call it, in part because it sounds like a really awesome Ikea bookcase. And in STVENG, sometimes you have to take risks . . .

JENNIFER: Did she happen to take one of those risks along the edge of a giant tub of wood varnish?

NANCY: WELCOME TO THE EMMY AWARDS!

PRODUCER: Good work, Nancy, keep smiling! You're a star!

JENNIFER: She's *deranged.*

AND THE TANOREXIA AWARD GOES TO . . .

The Tanorexia Award caused an unprecedented amount of discussion at the Go Fug Yourself Fug Awards Center for Fug. Normally the winners of our prestigious prizes are easily determined, so obviously worthy that we are able to run down the list, make our picks, and go out for darts and wings fifteen minutes later. Sometimes we're so anxious to get to the wings that we just use the darts to choose the victor.

But that wasn't the case in this instance. In fact, deliberations continued long into the night as we argued the relative orangeosity of each nominee. Jay Manuel was quickly discarded for maybe not actually being as fake-tanned as we thought. Nancy O'Dell and Lizzie Grubman were both rejected because we don't want to encourage either of them. This left KATIE COURIC, who's both old enough and smart enough to know better, and LUCY DAVIS, who veers wildly between Pale English Rose and Crispy English Bacon with such abandon that we're beginning to worry that she's actually got some kind of problem with her vision.

We went back and forth and back and forth, getting hungrier and hungrier and crankier and crankier. Do we recognize the old broad, or the young chick? Give it to Katie on the strength of her body of work, or award Lucy for truly going above and beyond? Finally, we decided: Screw it. Let's give it to them both. Those wings aren't going to eat themselves. Congratulations, girls!

The Dr. Nooooo!

Most

Tragic

Surgical

Choices

We're all familiar with the classic comedy and tragedy masks that are the international symbols for theater. Sadly, in Hollywood they represent something more sinister: the only two expressions available on many of the actors who go under the knife in the vain hope of escaping old age. So much for emotional range.

And so, with its obscenely pert buttock implants—because, seriously, isn't the very concept of a cosmetic bootyplasty a sign of the apocalypse?—the Dr. Noooooo! statuette goes to the celebrity who has most violated his or her face and figure in the quest for either eternal youth or grossly uneven sweater sandbags.

Faye Dunaway

Network, The Thomas Crown Affair, Dunston Checks In

So, this one is particularly painful. Back in the day, Faye Dunaway was totally gorgeous in a completely unique way. (If you haven't seen *Chinatown* or *Bonnie and Clyde*, you should watch them both, not only because they're quite good, but also because the clothes are totally fantastic in both of them.) *No one* looked like she did.

Today, of course, not even *she* looks like she did. Faye definitely has her fair share of the Priscilla Presley House of Wax thing going on (we're not kidding, just turn the page), but what really alarms us is her tragically misguided eye-lift. Faye's most unusual and beautiful feature, back in the day, was her hooded eyelids. She looked sort of sultry all the time. It was hot.

Now, not so much. We'd also mention something about the veneers, but we're scared she might bite us.

In all fairness, it seems strange that Faye would go for this dramatic an eye-lift. It's always interesting to us when people surgically alter the feature that makes them *them*. Call it the Jennifer Grey Effect: See, the dirty dancer got a nose job at some point, and it made her quite literally unrecognizable. She actually stopped

getting jobs because she suddenly looked so generic. Grey herself has admitted that she should never have had the surgery. There's a very real danger in fiddling with something that's so quintessential to your persona. And Faye seems smart enough—and old enough—to know that, which makes this particular choice a bizarre one on her part. We wonder if maybe this whole thing began as a mild attempt to freshen herself up, which went freakishly awry. We would rather believe that than think *this* is what she was going for, that's for sure.

Now, we've also heard rumblings that La Dunaway may be a bit of a nut—there's a rumor that she brings her own food when she eats in restaurants, which we love—so we've decided that when the bandages were unwrapped from her eyes and she saw what her surgeons hath wrought, she just unleashed holy hell on them for wreaking havoc on her interesting, delicate face. We hope—and firmly believe, whether it's actually true or not—that her surgeon is currently living in Guadalajara under an assumed name and sleeping with one eye open.

As will we be, after even bringing this up. We're sorry, Faye. We love you. Please don't hurt us.

Priscilla Presley
Queen of Graceland

You may remember Priscilla Presley from such hits as *Dallas*, the *Naked Gun* series, and her long-running role as Mrs. Elvis. Who could forget her and her enormous bouffant?

We like to imagine her taking that bouffant everywhere: to the kitchen to fry up some peanut butter and banana sandwiches for her honey, to the dry cleaner to pick up their weekly supply of jumpsuits, to the pharmacist to fetch his uppers and downers.

Now, of course there comes a time when a woman must put aside her bouffant and move on, and although we miss Priscilla's famous giant hair—despite never having witnessed it in our lifetimes—we don't begrudge Presley's

abandoning her ginormous tresses in favor of something more current. What we do begrudge is the fact that she also seems to have replaced her lovely, fresh face with a Kabuki mask.

She appears to have spent the past three weeks chasing the blood of virgins with a shooter of collagen, but maybe this photograph is misleading. Let's try another.

Huh. Third time's the charm?

Not so much. Stab her in the hand with a dinner fork? That's what she'll look like. Present her with the flaming head of her worst enemy? That's what she'll look like. Show her footage of a puppy rescuing a baby from a burning building? That's what she'll look like. It's creepy.

We certainly understand that it would be impossible for Priscilla to look as fresh-faced and young as she did way back in the day—we *are* aware of the aging process—but whatever happened to aging gracefully instead of retreating into this weird facial netherworld where it's impossible to tell how old you actually are, or whether you are, in fact, a reanimated corpse?

She is alarmingly extra-superfreaky waxen, and, frankly, her immovable face haunts our dreams. We worry. How can she teach her grandchildren how to sneer like Elvis if she can't even move her face?

Tara Reid

"Actress"

Poor, poor Tara Reid. In the past we've described her as: having breasts that "look as if she's got two half-grapefruits shoved in there"; "bad in like a bad, tacky, sad, I-Have-to-Stop-and-Pick-Up-Some-Ointment,Barefoot-in-the-Esso-Bathroom Britney way"; someone whose "behavior and appearance make Paris Hilton look like Grace Kelly"; and dubbed her "poor little Nips Akimbo, Child of Chestal Tragedy." And earlier in this book we begged her to Put It Away.

So maybe you could say that we've been kind of hard on her. But here's the thing: Those breast implants are really bad. Well, they *were* really bad. In 2006, she had them taken out. Or fixed and reimplanted.Or something. But despite their current absence from her chest cavity, the memory of them will never be erased from our collective unconscious.

I mean, could you forget these?

Seriously. They're not only the size of a toddler's oversized noggin, they're also saggy and uneven. If you're into saggy, uneven boobs, keep your natural ones, is what we always say.

It's particularly sad if you think about what she looked like without them.

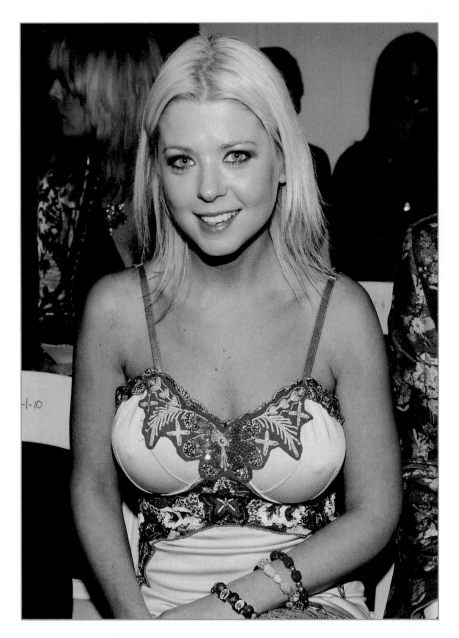

We find it hard to believe that even Tara thought it was an improvement to go from that to this. Unless she's campaigning for the role of Funbags Maloney, a femme fatale who bludgeoned a man to death with her rock-hard breasts, those are just over the top.

But if Tara Reid were merely the owner of some hideously malformed implants, she would not find herself in the running for this particular award. There are plenty of girls with bad boob jobs in Hollywood, and although Ms. Reid seemed—while in possession of them—to expose hers (unintentionally, but still) more often than most, they aren't the only thing that landed her here.

It is safe to say that we have never seen abs like this in nature. Abs can be taut and toned, or flabby and fleshy, or totally nonexistent, but they are definitely not supposed to be as they are pictured here: oddly lumpy and strangely dimpled, like homemade mashed potatoes.

Tara Reid has herself admitted that her stomach lipo went awry. For us, the question is why she felt she had to get the fat sucked out of her gut in the first place. Seriously, (a) she's not a shut-in, and (b) she's still totally young. If she wasn't happy about her beer belly, there's that old standby: work out and drink less beer. Or wear more blousy tops. Either. Both. We don't care. What we do care about is the fact that instead of going for an extra Pilates class or turning down that twelfth round of Baileys, or, you know, just accepting the fact that totally flat stomachs are overrated, she decided to go under the knife. Bad plastic surgery is bad. Unnecessary plastic surgery is bad. But bad, unnecessary plastic surgery is the worst, and for that, Nips Akimbo is our generation's poster child.

Kenny Rogers

Singer, *"The Gambler"*; actor, *Kenny Rogers as The Gambler*

Deep wrinkled creases
On a face marked with old age
Were ranklin' the Gambler—
He was too obsessed to sleep.

And he took right to starin'
In the mirror at his likeness
'Til paranoia overtook him
And he began to tweak.

Whether from the videos of his duets with Dolly, "accidental" viewings of *Kenny Rogers as The Gambler* and its many sequels, or the website MenWhoLookLikeKennyRogers.com, the beaming visage of country crooner Kenny Rogers is one we know well.

Aw. Hi, Kenny!

Snowy beard, gray-tinged hair, jolly smile, twinkling eyes... The man was, as seen here in 2001, one bowlful of jelly short of being Santa. Back then he more hilariously evoked his chicken-business rival Colonel Sanders, but without the glasses and the continued success. Cheer up, though, Kenny—however unwillingly developed his passion was, Cosmo Kramer will always love you, even if he can't buy your food anywhere but that one strip mall location in California. In our hearts and his, you are always roasting something delicious.

Still, overcome by the aging process (as so many celebrities with disposable income and nondisposable vanity are), Kenny didn't take kindly to his creases. Even here he had probably had minor work done on his eyes; he told *People* magazine in April 2006 that he'd gone under the knife a lot more "a long time ago," and if that's true, he had fared pretty well.

Until the tragic events of late 2005.

Then his surgeon went full throttle
Pulled his cheeks back to his jawbone
Lifted up his brow an inch
And made his eyes real tight.

So his face looked scary-awful
And he learned a painful lesson:
If you're gonna play that game, boy,
Get a surgeon who plays it right.

As it turns out, his surgeon was most definitely a moron. A terrible, tragic moron who owes Kenny a full refund and his services as a personal valet.

Hideous, right? The Gambler not only didn't know when to hold 'em, but also failed to recognize a golden opportunity to fold 'em. Kenny Rogers, our island in the stream with no one in between, showed us how he *could* be wrong.

He looks like a manic rabbit, as opposed to the merely friendly rabbit he resembled before. Inside, we know he is crushed that the MyHeritage.com celebrity facial-recognition software thought he was Gary Busey, and is seriously considering rectifying it on *Dr. 90210*.

Or, failing that, a self-parodying episode of *Nip/Tuck* in which he plays an aging country singer and chicken entrepreneur who wants Christian to remove his face and replace it with that of Clay Aiken. Hey, if you're trying to look younger, go all the way.

Hunter Tylo

The Bold and the Beautiful

The story of Hunter Tylo's best-known and most beloved soap opera character, Dr. Taylor Hayes Forrester Forrester Forrester Marone, is so crazy it verges on the cartoonish: She fell in love with a man named Ridge (yes, Ridge, who accounts for all three of the Forresters in her name) while counseling him during and after his wife's death; was trapped in a cabin with a male friend during an earthquake and, despairing survival, compassionately devirginized him; was presumed dead after a plane crash but had actually been rescued and rehabilitated in the Middle East by a man named Prince Omar; birthed Ridge's twin daughters during a near fatal bout of tuberculosis; got shot in a scuffle and died in a weepy and prolonged hospital scene surrounded by her loved ones; returned a year later when it was revealed that when her machines beeped and the doctors pronounced her, she was only *mostly* dead, and Prince Omar *again* had whisked her near lifeless body back for another magical desert resurrection, thoughtfully planning ahead and procuring a lifelike bust of her to place in the coffin for that tricky open-casket wake; and then wrestled alcoholism and accidentally killed her brother-in-law's wife in a boozy car accident.

And that's just a light synopsis. It's apt, then, that Hunter's face and body have started to look *equally* crazy and cartoonish.

The transformation of Hunter Tylo seems to have taken place in phases. She

hasn't admitted to any plastic surgery, but let's take a look at her through the years to see what we think. This photo is from 2001.

It's incredibly unfortunate that the fashion show at which she's modeling has demanded that she wear a translucent monstrosity evoking images of a Star Trek–themed lingerie line—*The Sexed Generation*—but at least her chest does not appear to be twisting out at unnatural angles.

We cannot say the same for her in 2002.

Thanks to the fact that her *Little Mermaid Goes to the Prom*–themed evening gown can't find a way to cope with what's brewing, something seems to look amiss with her chest. Still, her face remains malleable—badly made up, but still pretty; it looks as though if you tickled her, she would be able to crinkle it in mirth without fear of anything cracking or falling off.

This was taken in 2005. A woman considered among the most beautiful in soaps looks suspiciously like she was abducted by aliens who sent back in her place an extraterrestrial replica on a secret mission to infiltrate CBS's studios and bring back old *The Price Is Right* sets for use in an intergalactic variety hour. When asked in 2006 how she felt about aging, she told *Soap Opera Digest*, "It *can* be done with grace, and women shouldn't be ashamed of getting older," yet she refused to answer whether she'd had plastic surgery herself.

Perhaps she was merely overcome by how stupid the question is. And although we're sure Dr. Taylor H-F-F-F-M has taken her fair share of smacks from her romantic rival, Brooke Logan Forrester Forrester Chambers Forrester Forrester Jones Forrester Forrester Forrester Marone (to her credit, five of those were later invalidated, and she mixed it up among three *different* Forresters), no open-palm slap could possibly yield the kind of lip-stiffening that's visible in this photo.

And the chest. The *chest*. We know Mother Nature can be cranky, but unless she made Hunter's chest the modern-day equivalent of Pinocchio's schnoz, we're not sure how this would have happened without intervention.

Or maybe it's all an illusion because she keeps buying awful dresses. What do you think?

AND THE GILDED BUTTOCKS GO TO . . .

With the glory of taking home this award possibly balancing out his sad facial renovation, we like to think that **THE GAMBLER** has broken even.

The Pits and the Pendulum

Most

Maddeningly

Inconsistent

Dresser

In some ways, the grievous errors of a walking wingnut like, say, Britney Spears are the easiest ones to understand. She may be bad, but she's dependably bad, and we're getting to the point where we know what to expect from her: She loves short things—*very* short things—and she prefers not to run a brush through her hair. No matter how intermittently she tries to hide it, she'll still spend her weekends going barefoot as often as possible, regardless of the condition of the gas station floor.

 onversely, the nominees in this category are people of vexing inconsistency. They are quite capable of good, nay, *great* fashion decisions, yet oftentimes . . . simply don't make them, to the point that when they slip, it seems even *more* tragic when compared with their big hits. The pendulum doesn't simply hover, nor does it swing lightly; it *whips* back and forth to the outer edges of its range, and we're just along for the ride, feeling a little motion sick.

The lucky winner will take home a very rare Edgar Allan Poe anthology autographed by Britney Spears herself.

Beyoncé

Dreamgirls, Austin Powers in Goldmember; singer

In December 2006, Beyoncé Knowles informed *Parade* magazine that she has a split personality. When she's onstage, she said, she transforms into Sasha, whom she claims she "wouldn't like [if she] met her offstage." Apparently, Sasha is "too aggressive, too strong, too sassy, too sexy!"

This sounds a little nutty, but if you carefully examine Beyoncé's wardrobe choices over the past few years, you'll notice that her body *does*, in fact, seem to be dressed by two entirely different women.

SASHA: I love this! It's so FESTIVE and SASSY. I've always wanted to look like a human piñata! We are WEARING THIS OUT!

BEYONCÉ: Are you sure? It's a little . . . much, don't you think?

SASHA: MUCH IS MORE! I'm in charge today! WE'RE WEARING IT! GOD.

BEYONCÉ: *(sigh)*

SASHA: Booooooooring.

BEYONCÉ: Or, elegant and classic. It's very appropriate for the Oscars, I think.

SASHA: What about a headdress?

BEYONCÉ: No, I told you: I want to look chic and glamorous, and it's my turn to dress us. Please, don't argue with me anymore.

SASHA: You are SUCH A SNORE. You know what this means.

BEYONCÉ: Please, Sasha. No.

SASHA: Next time I am TURNING IT UP.

BEYONCÉ: *(sigh)*

SASHA: What did I tell you? Man, this is hot. No one here is ready for this jelly!

BEYONCÉ: This is so embarrassing. Why are we blond?

SASHA: Why are you still talking? I'M in charge tonight.

BEYONCÉ: Are you sure I can't interest you in a nice pencil skirt? We could leave the jacket on, but—

SASHA: NO, NO, NO, NO, NO, NO, NO. I am wearing HOT PANTS tonight and THERE'S NOTHING YOU CAN DO ABOUT IT. Now, let's go say hello to Charo. I want to know if she'll loan us her boa.

BEYONCÉ: *(sigh)*

BEYONCÉ: But it *is* metallic, Sasha.

SASHA: I guess.

BEYONCÉ: And a little low-cut. Don't you like it? I think it's a good compromise between sexy and chic. It's really the best of both worlds.

SASHA: Whatever.

BEYONCÉ: I can't believe you don't like this.

SASHA: *"I can't believe you don't like this."* You're so passive-aggressive.

BEYONCÉ: Everyone else thinks we look marvelous!

SASHA: Everyone else would have LOVED IT if you'd cut a huge slit up the side and worn Charo's boa LIKE I WANTED.

BEYONCÉ: Well, it's not your turn, Sasha.

SASHA: I don't think I'm talking to you anymore. Call me when Jay-Z gets here.

BEYONCÉ: *(sigh)*

Cate Blanchett

Elizabeth, The Aviator,
The Lord of the Rings, Babel

Blah, blah, blah, great actress; blah, blah, blah, incredibly talented; yadda, yadda, yadda. Can we talk about her outfits for a sec? Because we think that Cate Blanchett, like many talented artists, might have a spot of the crazy.

It seems to emerge primarily when she's standing in front of her closet. Now, it must be pointed out that Blanchett's "bad" is rarely vulgar or cheap—her errors are generally more in the vein of, "I thought I could pull off this incredibly theoretical, postmodern, metallic couture thing. But it turns out that I cannot." We have to give her points (say, 100) for being ballsy without being tacky. Several nominees even in this category would do well to take note.

But we have to subtract points for this outfit: She looks like she's appearing in a musical about the last days and death of Tutankhamen in the pivotal role of Anubis, the Egyptian god of death. Subtract 50 points for the weird neck/shoulder thing, 64 points for the fact that we think we saw this in the "Walk Like an Egyptian" video, and 76 points for the fact that her head looks like it was Photoshopped onto her body. That puts her at negative 90 style points.

She'll make up some ground with *this* metallic number, though, which is a vast improvement. It's unusual and interesting, the sort of dress you toss on after you sing a spirited rendition of "Let's Go to the Movies" to a plucky orphan in your dressing gown. For evoking the sacred spirit of *Annie*, we award her 67 points.

Let's see if she can improve on that in this next selection.

Bingo! She gets 23 points up front just for looking cool and collected and delicious while gestating. If we were pregnancy fetishists, we'd say she looked like a juicy, ripe cherry, but instead we're simply going to applaud her for looking sexy and gorgeous and not one bit as if she's suffering from any kind of swollen ankles or back pain. It's like she's reenvisioned Scarlett O'Hara's infamous red Everybody-Knows-I-Want-to-Bone-Your-Husband-but-I'm-Coming-to-Your-Party-Anyway-and-I-Look-FANTASTIC gown, except minus the guilt and plus a fetus. She gets a bonus 76 points for that color alone.

And she loses them all for sullying that same color here, proving that she's just as capable of screwing up her casual clothes as she is her formal wear.

Seriously, we know the eighties have kind of come back, but is a knit tie EVER okay? Especially with a striped suit and sweater that—holy heavens—*coordinates* with the tie? This thing is matchy-matchy in a way that is both precious and unflattering, not to mention the fact that the tie draws your eye right to her crotchal region, and while we're big, big fans . . . Keep your crotch to yourself, we always say.

We hate to end on a bad note, but let's do the math anyway. Okay . . . wait, hang on, we're not fantastic with math, which is one of the reasons we farm out the accounting for this thing . . . oh, interesting: It comes out to a nice, even zero.

Huh, well, that seems about right.

Fergie

Singer

The radio edit of a famous Black Eyed Peas song—the version embraced by every single sporting arena in America and beyond, to the point where we can't figure out why they didn't just write it that way to begin with—entreats us to "get it started" while the original prefers the more sensitive approach of encouraging everyone to "get retarded." And that basically encapsulates the wild differences in singer Stacy Ferguson's dress sense. Sometimes she gets it shockingly right; the rest of the time her lovely lady lumps would be better off going down with London Bridge.

When Lady Fergalicious first usurped the Duchess of York's throne as Best-Known Person Named Fergie, she fancied herself hip-hop chic. She was a fan particularly of jaunty caps, formal shorts, and braids so long and thin she could use them as dental floss. Here she added a shirt and necklace we suspect she might've ganked from a locker at the local country club. Somewhere on the eleventh green, Peony Chadworth-Bates is putting for par, blissfully unaware that the top she'd planned to wear for lunch at the spa has been purloined by a woman who once peed herself onstage. This entire ensemble is an audition for *Caddyshack III: Wack Rhymes and Tee Times*.

And yet, Fergie Longstocking is perfectly capable of looking normal.

See? She's happy, she's chic, and she doesn't look like she was just rejected from the West Palm Beach Convalescent Home and Community Dinner Theater production of *Oliver!* Everybody wins.

Unfortunately, though, the fashion gods won't stop flipping the Fergie coin.

Perhaps someone erroneously told her that one's ensemble is a window to the soul, and she assumed her soul was located somewhere in the vicinity of her nipples.

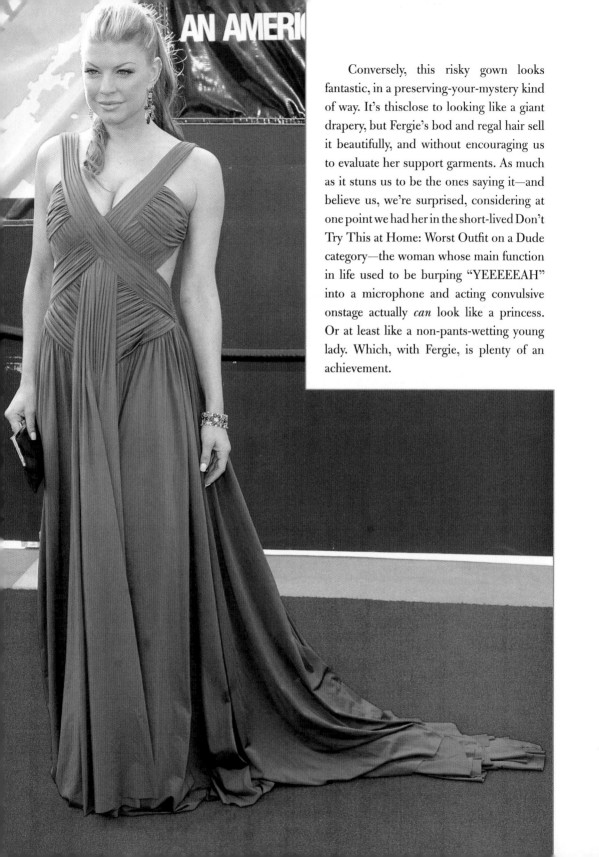

Conversely, this risky gown looks fantastic, in a preserving-your-mystery kind of way. It's thisclose to looking like a giant drapery, but Fergie's bod and regal hair sell it beautifully, and without encouraging us to evaluate her support garments. As much as it stuns us to be the ones saying it—and believe us, we're surprised, considering at one point we had her in the short-lived Don't Try This at Home: Worst Outfit on a Dude category—the woman whose main function in life used to be burping "YEEEEEAH" into a microphone and acting convulsive onstage actually *can* look like a princess. Or at least like a non-pants-wetting young lady. Which, with Fergie, is plenty of an achievement.

Teri Hatcher

Desperate Housewives, Lois & Clark: The New Adventures of Superman

Dear Teri,

Congratulations on all your recent success. We're sure you have reached new, exhilarating highs in your career; we admit that, yes, we are taking other people's word for it because we didn't read your memoir, *Burnt Toast: And Other La Di Da Yawn We're Not Really Sure What This Was Exactly*, and we stopped watching *Desperate Housewives* back when it ceased being madcap and just made us mad. Besides, in our hearts you will never surpass the glories of your role as Ariel Maloney in 1991's *Soapdish*, where (a) your character's *The Sun Also Sets* alter ego, Dr. Monica Demonico, wore tiny white dresses and pined for Bolt, the spandex-clad, leg-lift-crazed husband of Sally Field's soap character; (b) your actual character helped bust the evil Montana Moorehead (Cathy Moriarty) on her secret past as a man; and (c) you got to respond to Kevin Kline's compliment on your eyes with, "They're nothing compared to my tits."

Come to think of it, back then you seemed to like being known for your breasts. Between that and the *Seinfeld* episode that was built around whether your rack was real or enhanced—"They're real, and they're *spectacular*"—you've hung quite a lantern on your lady melons. We will never be able to ignore them, ever. Not after Elaine went to such accidentally grabby lengths to give them an investigative prodding.

Did you grow tired of your breasts' notoriety, Hatch? Were you upset with them when their fame outsized your own? Is that why, now that you're back in the driver's seat, you decided to drag our attention farther downward, or upward, at all costs?

Because props to you—it worked. Your breasts are pretty much the last thing we are concerned with here. It's impossible for us to look at this photograph without wondering why, God, WHY you decided to show up in hot pants and a brothel's best bed linens. Or what precise form of gladiatrix battle you've just come from with those old-school Roman sandals, two black eyes, and a Civil War–era slip that demands a hoopskirt mechanism and, oh yes, SOMETHING WORN OVER IT.

Teri, Teri, Teri. Why the fulfillment of your hit show's suggestion of desperation? You had a Golden Globe! You had an Emmy nomination! You hadn't pretended to date Ryan Seacrest yet, and no one was telling stories about you and Marcia Cross wanting to burn each other in effigy, so people still pretty much liked you!

Had you forgotten that you could, and *can*, look sexy without looking like you're in the sex trade?

These two perfect dresses offer a tantalizing peek at your assets, as opposed to sticking them all in the store window with a neon CLEARANCE SALE sign underneath. And for what it's worth, you look a lot happier in these than in that goth stripper getup from the Grammys.

Just a tip, though, Teri—it's not the greatest idea to run around town looking like you snagged your head on a Christmas tree skirt. We're only scolding because we care. Okay, that's not exactly true; we're scolding because we're nothing but charred husks with icy veins. Still, take the tough love and run with it—preferably as far away from fur-trimmed dust ruffles as possible.

Regards,
The Fug Girls

P.S. Do you get along well with Marc Cherry? Because if you could get him to hire Thomas Calabro as Marcia Cross's love interest so that we might have a glorious reunion between Drs. Kimberly Shaw and Michael Mancini, we would be forever in your debt. Perhaps not enough to stop us from ripping on your clothes, but we'd at least owe you a pasta dinner.

Diane Kruger

Troy, National Treasure, National Treasure: Book of Secrets

Diane Kruger, unlike many of her contemporaries, is sort of an enigma as far as her personal life goes. We know she's German, and she was once a model. Or a ballet dancer. We're not entirely sure. IMDb.com tells us that she shares a birthday with postmodern theorist Jacques Derrida and *Beverly Hills, 90210* songbird Brian Austin Green, proving once again that there really IS something to astrology. We've heard that she might be dating Joshua Jackson. (It's true: *Everyone* loves Pacey Witter.) Frankly, it's kind of refreshing not to have to go through endless articles like DIANE'S CHILDHOOD PAIN: HOW MODERATE ECZEMA TOTALLY BUMMED HER OUT or 'I DIDN'T SLEEP AT ALL': DIANE'S FIGHT AGAINST JERKWAD NEIGHBORS or whatever.

Knowing almost nothing about her also gives us the opportunity to make up any number of plausible or not-so plausible excuses for outfits like this one—say, DIANE'S 'BIRDS OF A NETHER': AS A RARE STRAIN OF AVIAN FLU ATTACKS THE GERMAN STARLET, SHE LEARNS WHAT IT MEANS TO FIGHT FOR HER LIFE, perhaps.

DIANE'S AWARDS-SHOW TRAGEDY:
'MY GOLDEN GLOBES WERE ASSAULTED BY MY SHOWER CURTAIN'

'WE THOUGHT SHE SEEMED KIND OF OUT OF IT': DIANE KRUGER'S FAMILY SPEAKS OUT
AFTER LEARNING THE STARLET'S BEEN LEGALLY BLIND FOR MORE THAN FIVE YEARS

And because we've invented all these baby-in-the-well-type tragedies to explain Diane's fashion missteps, we likewise feel free to confabulate any number of reasons to explain what could possibly clear up her fashion brain-fog on the occasions when she shows up looking grand:

KRUGER LAUNCHES SIDE GIG AS HIGH-CLASS MAIL-ORDER BRIDE, MAKES MILLIONS

DIANE KRUGER'S OCCASIONAL BLINDNESS CURED BY CHOCOLATE CAKE: SHE LOOKS
GREAT, DOCTORS SUGGEST EVERYONE EAT SOME

DIANE'S GOLDEN GLOBES TRIUMPH: 'I TOTALLY OVERCAME
THAT TIME I WAS ASSAULTED BY MY SHOWER CURTAIN'

On the whole, we must admit that Kruger's bad moments are
REALLY bad. The bird skirt? Is she on Jim Henson's payroll?
Is she working some kind of I'm-a-Wacky-Creative-European angle,
hoping that Americans will just shrug and ask if this is the time
on *Sprockets* when we dance? Because if so, we're not going to fall for
that one. Not again.

AND THE FUG AWARD GOES TO . . .

This may be one of the toughest categories we've faced. Staring at all these tragic photos and triumphant photos has given us whiplash.

Teri and Fergie don't seem to have reached quite the same levels of ingenuity and inanity as the others, and Beyoncé . . . Well, by trying to invent some kind of adorably clinical reason for her fashion yin and yang, she's kind of sucked all the *organic* crazy out of it. So that leaves us with Cate and Diane, and as our nation always does in times of trouble and indecision, we're turning to the only answer we know: vodka.

Okay, no, not really. We don't need Comrade Smirnoff to hand-

hold us through this one. Not this time. As bizarre as Cate Blanchett's choices can be—we still aren't over the knit tie; was she *trying* to evoke our middle-school science teacher?—she still scores more often than she strikes out, and the chances she takes are at least moderately explicable. There's logic. You can see a kernel of a recent trend, or she's experimenting with color, or she's wearing something that's at least hot off the runway even if it's controversial.

And that's why this award goes to **DIANE KRUGER**, a woman whose ups and downs are just that little bit more pronounced and borderline deranged. A ring of feathers? A curtain dress? We can't tell *what* she was thinking, unless it was "Little Girl Lost . . . in the Hobby Barn."

The Cher

When the subject of dressing outlandishly pops up, as it so often does, the first name on everyone's lips is generally Cher. Glorious Cher of the spangled Bob Mackie originals, Cher of the extravagant sequined headdresses, Cher of the prodigiously exposed navel. Cher, Cher, Cher! "Why don't you fug Cher?" people ask.

ell, we can't. She's CHER, people. Cher! She can pull off anything—*anything!*—she tries, simply because she is CHER. She has a lifetime under her bedazzled belt of wearing hot pants and coconut bras. She was wearing a feather boa and lamé thigh-high boots before we were born. Cher is Cher, and Cher rocks.

But she is not alone. There are those few, those proud wonders of celebrity who manage, by the pure magnetic force of their personality, to get away with wearing anything they want simply because of who they are. Five such people are in the running for the Cher Award, all of them so kooky that we can't judge them by the same standards we use to critique Jane Starlet. Some of them are living legends. Some of them are Madonna. And tonight one of them will take home the trophy. What better way to say "You're crazy and we LOVE it" than by handing out a naked chick with a disco ball? We think Cher would approve.

Björk

Dancer in the Dark; singer

Believe it or not, Björk *did* exist before the 2001 Academy Awards. But there's something about the sight of a woman wrapped in a stuffed swan that makes anything that came before seem boringly devoid of wearable swans.

However, the Icelandic pixie is *so much more* than mere water fowl. Björk is *also* apparently some sort of intergalactic high priestess.

At first glance to our uncomprehending Earth eyes Björk appears to be the solution to a Clue mystery— Miss Scarlet, in the press room, with the Q Award. But we believe this photo makes a compelling case for Björk as an Ambassador of Irreverence from the planet Kook, and that she has been photographed here wearing the traditional formal crimson robes reserved only for her homeland's most prestigious occasions (coronations, funerals, interplanetary beer-pong festivals). We think she's transmitting information via a sacred statue, kind of like on that old late-eighties show *Out of This World*, where the half-alien Evie tried to live a normal Earth-bound life despite her secret powers but sometimes needed to crack open the big crystal cube on her dresser in order to chat up her absentee father, Voice of Burt Reynolds.

We could be content to think that Björk is simply singing into a microphone and only *happens* to be in a blousy tunic romper painted like butterfly wings. But we prefer to theorize that in her role as a cultural liaison from beyond the reaches of the Milky Way, she has accidentally confabulated certain cultural details and is in the midst of an embarrassing monologue from what she believes is our favorite play, *Madame Butterfly McQueen*—the story of a young Japanese girl who meets an older military man, gets involved with him, follows him to Georgia, announces she don't know nothing about birthing no babies, and then kills herself in a shocking act of hara-kiri involving a curtain rod.

Of course, the pink cotton-candy confection we don't think has any kind of alien explanation. It's probably exactly what it appears to be—a blatant visual plea to her planet's favorite entertainer, Céline Dion, for a bridesmaid role in yet another lavish vow renewal ceremony (but, of course, Céline would dub this outfit "not sufficiently conducive to elephant riding").

What we love most about Björk is how casually and calmly she wears these loopy outfits. It's as if she can't figure out what all the fuss is about because back in her galaxy, she was considered rather vanilla. And so over time we've stopped seeing her as loopy and started realizing she may well be royalty on our planet *also*. Fug royalty. The kind whose reign you hope will never end.

Flavor Flav

Flavor of Love, Strange Love, The Surreal Life; rapper; timepiece aficionado

Flavor Flav's reality show, *Flavor of Love*, was a train wreck. But as train wrecks go, it was totally watchable, mostly because of how delightfully weird he is. For the uninitiated, it was basically *The Bachelor*, but instead of featuring some low-level heir, Flav is the man-prize. Arguably, the best part of the show is when Flav renames his ladies. He's ostensibly decided that he can't remember their given names, so he has to make up nicknames for them (which he will then have to remember anyway, but let's not quibble over the details). The way it works is, he eyeballs each of the girls, and then says something like "You seem crazy. I'm going to name you Crazy." But then he writes Crazy's name on a Post-it or whatever, and it's spelled KRAyZZeey. And then the next one is named New York, even though she's from Jersey. And then the last one he decides to call Sharon, or something. It's kind of kooky and brilliant.

Given all that, it should be no surprise that Flav is a man who thinks nothing of wearing giant Viking horns all over the place. We like to believe that, in the privacy of his own home, he's totally drinking orange juice out of this hat.

In addition to the horns, of course, is his trademark: the ginormous clock worn around his neck.

He always wears the clock. On the red carpet, on the sofa, in the shower (we presume). Does he have a punctuality problem? Is he a huge fan of Eli Terry, the father of American clock mass production? Is he making a statement along the lines of "Time flies" and thus subtly urging us to gather our rosebuds while we may?

In a way, Flav is like a children's television show host, adorned with strange, oversized, amusing accessories. And just as we have no interest in knowing why Mr. Rogers was so fond of cardigans, we don't really want to know the reasoning behind Flav's love of timepieces. He wears a big giant clock around his neck, period. No explanation necessary.

Grace Jones

A View to a Kill; singer

If the snuggly, warm visage of fellow nominee Dolly Parton makes us wish she were our fun-loving aunt, then photos of Grace Jones evoke that family friend we *treat* like an aunt but who really just went to college with our parents and always used to bring us crazy and somewhat inappropriate gifts and souvenirs in addition to sneaking us booze and cigarettes and cultivating our inner dark-side rebel. She's the lady we don't realize we miss until she comes back around again, at which point we can't imagine how we ever survived without her.

Seriously, look at this. It's genius. We mere mortals may not immediately understand the wisdom of wearing a scrunchie from the planet Gargantua around our necks, but Grace Jones is on a different plane. She sees this not as something Satan's girlfriend might have tossed in her gym bag, but as the perfect complement to her beloved black nylon forehead sock. Before the Red Death, her stretchy mask was merely an accessory to a divinely batty ensemble of blue leather gloves, a tulle drawstring purse, and a Michelin Man fur. But after destiny draped that volcanic lei around her neck, it all made transcendent sense. (As a bonus, it hides the seams on the black straw mat she sewed into a skirt.)

Aside from her incomparable yet incomprehensible vision, there is something else that makes Grace Jones so divinely, deliciously Grace Jones: Her complete lack of fear.

Were either of us wearing this fur turban, you would see written all over our faces, "Oh God, this turban is SWELTERING. And HEAVY. Is it falling off? I think it's about to fall off. Also, I can't turn my head. And did a bird just try to lay eggs on me?" However, Grace Jones is having none of that. She is working it. Grace Jones is strutting through whatever function she's at—we thought it was an airport at first, but actually it looks a bit more like a church social—and she is *owning* that turban. She is thinking, "I can't believe they're out of ham sandwiches already." She has no cares in the world except, perhaps, where her driver is. And she's not afraid to let an electric blue purse compete with the turban, because she knows that no one can tear his or her eyes from how well she is pulling off what is essentially a large furry floor pillow.

Of course, she also knows how to demand attention just in case she isn't already commanding it.

This is a true portrait of majesty. The pantsuit appears to be made from those rolls of thin foam packing material, but spray-painted gold—making her a veritable trophy of mystifying splendor— and then corseted for good measure.

In sum, we love Grace Jones even though we could never hope to understand her. And we cannot, no matter how hard we try, refer to her as "Grace" or "Ms. Jones" or "La Jones" or "G. Jo" or any other perversion of this blessed, perplexing entity's name. She is Grace Jones, and she is the mistress of a domain that is uniquely her own. She cannot, nay *must* not, be contained.

Madonna

We suspect you've heard of her

Oh, Madonna. You were very important in our youth. We must have spent hours prancing around with our training bras fastened over our T-shirts, waving our fingerless-gloved hands in the air and singing "Like a Virgin" before sitting down and thinking very seriously about how if Madonna feels *like* a virgin, that must mean that she isn't *actually* a virgin now and oh my God, SCANDALOUS! Then we wrote a few love letters to Michael J. Fox and thought about how awesome it was going to be when we took over the title role in *Annie*.

Well, we've given up on becoming Mrs. Michael J. Fox, and we're pretty sure we're too tall to pull off Plucky Orphan now, but we still have a soft spot for Madge. She's built a career around revolving, costume-heavy personas: She's a virgin! She's a nun! She's a geisha! She's a bullfighter! She's got incredibly pointy breasts! Lately she's been one of the extras from the final scene of *Xanadu*—you know, when everyone is roller-skating around making Xs with their arms and Gene Kelly is wondering how the hell he ended up here.

This is what pirates look like right after they've just come out of the closet and they're all about hitting the gay pirate bars and the gay pirate circuit parties and throwing their gay piracy in their parents' faces.

But Madonna is nothing if not a woman of many faces. Sometimes she's parading around like the world's most fabulous aerobics instructor.

If we got to wear outfits like this to Step Aerobics Fitness II, maybe we would have actually *attended* Step Aerobics Fitness II.

Here is Madonna . . . as JESUS. See what she's doing there? Madonna has always played with traditional aspects of Catholicism, but literally dressing up like Jesus Christ kind of takes the wafer. And there's something to be said for the fact that our reaction to Madonna in a crown of thorns is not, "BLASPHEMY!" or, "Who does she think she's KIDDING?" or, "What is her PROBLEM?" or, "I am APPALLED!" but rather, "Oh, okay." We've had so many years of bizarre and shocking fashion choices from Madge that now almost nothing she does can really shock us.

Which probably makes her sad, but we find it kind of soothing.

Dolly Parton

Singing legend, actress

We've theorized that some of the nominees in this category are out of this world in a very real sense—that their closets are thrilling pieces of mischief that no one's meant to understand but them, because they're not of this realm.

Dolly Parton is not one of those nominees. She's all down-home flavor—a Tennessee girl with big hair, big jugs, a big personality, a big addiction to anything shiny, and a sense of fun that outsizes all of the above (yes, even her Twin Peaks, unofficially the Eighth Wonders of the World). The woman has a theme park of her own, for crying out loud. And as entertaining as Björk Gardens, Material World, Six Flavs Great America, or Graceland Jones would be, we're pretty sure Dolly Parton is the only person in the world who could pull off an eponymous amusement park as if it were the most normal thing in the world. After all, hey, she pulls off that chest; a ferris wheel and log flume are nothing.

Just look at her. She knows exactly who and what she is—pure outlandish goodness, every last sassy inch of her. Dolly Parton is the only person in the world who could: (a) take a jacket that looks like she stole it from a beheaded French nobleman; (b) pair it with spangled denim bell-bottoms that have built-in ankle petticoats and a zipper so long she needs a boathook; (c) make the whole thing look so fun that you kind of wish you ALSO could dress like a member of a *Dangerous Liaisons*–themed marching band.

It's admirable, really, the way she can not only turn any outfit at all into a campy delight, but also somehow make you crave a taste of her gumption. You've never wanted gold appliqués on your clothes before; why now? Because Dolly makes the insane seem incredible.

See, Dolly just seems so *comfortable* in her skin. So she's wearing a skintight baby blue leather jacket with gold trim, matching knickers and pumps, and a swath of electric pink lipstick designed to complement that manicure. The question is, why aren't *you*?

Or there's this fluorescent bandanna of a dress, paired with gold pumps and a waterfall of fringe. A holy off-the-shoulder terror? Yes on anyone else, but Dolly's all, "Honey, this fringe is the most fun I've had since they invented wig tape!"

Even as she embodies the extreme of every country stereotype (spangles! Dipped in gloss! And rolled in glitter!), Dolly Parton knows exactly what she's doing: She's being Dolly Parton, and Dolly Parton is Larger Than Life. When she hops onstage in one of her getups, she does it with a wink and a smile. Because that's who Dolly Parton is, and she's happy and she's a legend and sheeeeeee will alwaaaaaays love yooooooooooou in a sincere way that Whitney Houston never could.

AND THE DISCO BALL
GOES TO . . .

Every morning, each of these brilliant nominees takes one more step toward ultimate Cher-itude. Every futuristic tunic brings Björk that much closer to belting out "I Got You Babe" in Icelandic. Each giant timepiece lands Flavor Flav one millisecond nearer to a lifetime of palling around with a short man in a bowl cut. We're not entirely sure what the heck Grace Jones is wearing, but she could certainly wear it if and when she manages to turn back time. And every day of her life, Madonna inches ever so slightly closer to prancing around wearing duct tape and fishnets aboard the USS *Missouri*.

But the real heir to the throne—the woman who may, in fact, already be out-Cher-ing Cher—is **DOLLY PARTON**.

We applaud her unapologetic enthusiasm for her fake hair, giant boobs, plastic nails, and all things shiny and sparkly—and we're dying to take a tour of her wig closet, or try on her corsets. Of all the nominees in this category, Dolly's over-the-top fabulousness feels the most uncalculated, the purest, the most joy-filled, and therefore the most worthy of positive recognition. Dolly is Dolly not merely from nine to five, but twenty-four hours a day. For that, we salute her.

Also, we sort of want her to reunite with Dr. Noooooo! winner Kenny Rogers for a modern remix of "Islands in the Stream," and we suspect this may be a way to facilitate it. They can get to chatting about their Fug Awards, she can assure him that his plastic surgery isn't THAT bad, they'll go out for coffee, and boom: We're all sailing away to another world. You're welcome, America.

The Cher-Alike

Some people are born into greatness; others merely work toward it. And then there are those who act like they were born into greatness, all the while furtively groping for it with the clumsy greed of a junior high school boy thinking his first kiss under the bleachers might take his clammy palms all the way to second base.

 her and her outrageous, magically delicious ilk are honored in the previous category, but the Cher-Alike nominees have a rarefied air of entitlement, often unearned or inexplicable or too prematurely self-awarded. They have not ascended to that glorious place where they can, say, wear a sequined bustier and hot pants with fishnets and get away with it, or don three hooded sweatshirts for a red-carpet party and expect people to turn a blind eye. They want to be able to get away with everything, and they believe they already do. In short, they're the people you look at and say with a snort, "Who do you think you are, Cher?"

The nominees for the Broken Headdress are a onetime rocker, a onetime rocker's wife, a wannabe rocker, a wannabe *anything*, and the girl who sang "Wannabe."

Victoria Beckham

Spice World, her career with the Spice Girls, her spicy life as a real footballer's wife

Being a Spice Girl catapulted Victoria Adams into the limelight, but marrying footballer David Beckham kept her there. Sure, she could bumble her way through awkward choreography with a woodenness all her own, and yes, she could warble her part in a five-part harmony with something faintly approaching adequacy, but who cared? What *really* mattered was what she was wearing, the condition of her hair extensions, whether she was pregnant, whether David was cheating, whether they seemed happy together when out in public, whether she was being stalked and/or threatened by kidnappers out to swipe her children, whether she'd had plastic surgery, whether she would ever have a solo career, and, of course, whether she ever ate anything at all.

Somewhere amid all this speculation and scrutiny, Posh and Becks became England's most celebrated couple, treated like an extension of the royal family by their adoring yet occasionally cheeky public (let's not forget when they were made Mary and Joseph in a wax Nativity scene). But between occupying a constant place in the headlines and being crowned by one and all as the queen of the WAGs—Wives and Girlfriends of England's heroes on the pitch—our Vic may have gotten a bit blinded by the spotlight and forgotten that she is not, in fact, *actual* royalty.

Not many women would dare to step out in this . . . this . . . well, it's got a train, it's got patches of lace, it's lousy with gold leaves, and that *might* be poultry down there at the bottom. It's a dress that can be worn only by somebody who believes utterly in her own royal bearing. So although David's the one famous for how he bends them into the goal, it's Victoria whose balls we've grown to admire.

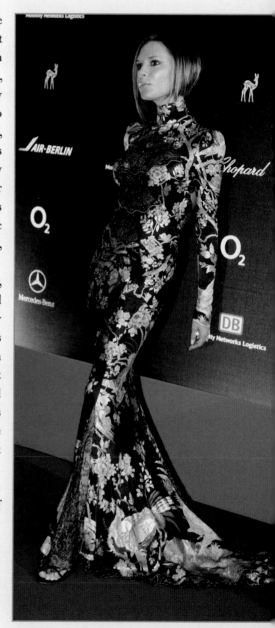

Want to act like you're the guest of honor at a cocktail party aboard a yacht off St. Tropez? But of course! And the more boob tape required, the better.

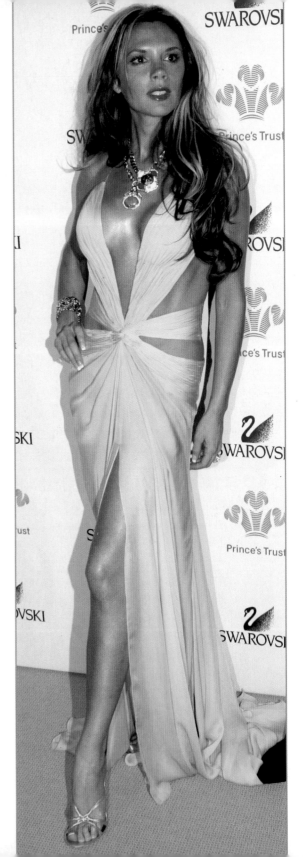

Want to dress up like a mermaid, Posh? Sure! No slit is too high, no plunging neckline too deep, no spangles too spangly.

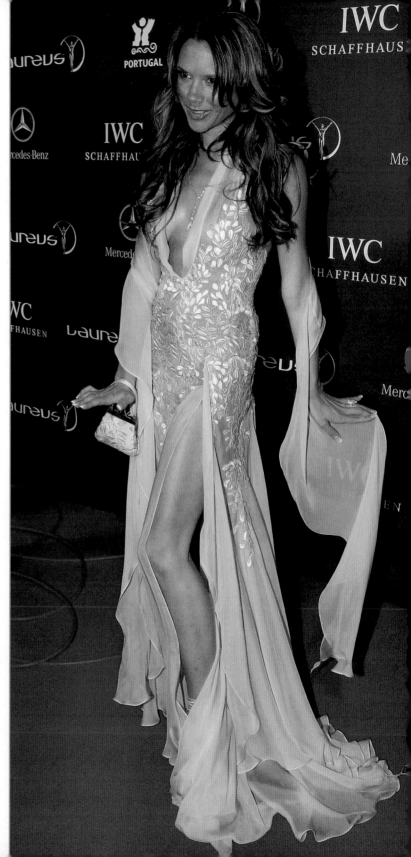

How about a tutu—any objections?

Not bloody likely! Not only will she wear it, but she'll pair it with a shirt that her son Brooklyn designed in his grade-school art class, even if it does mean she has to walk so stiffly all night that she may as well be made of plastic.

Don't get us wrong: We love her. No, we *love* her. We adore that Posh and her rail-thin figure try to get away with risque outfits and a posture so icy, so aloof, that even all-star arm-candy designers like Roberto Cavalli start to back away to avoid frostbite. We devoured her memoir, *Learning to Fly*, and her 2006 book of style tips was hand-carried to us from across the pond when it was published in England but hadn't yet hopped the ocean. The three of us share an obsession with things like shoes, day dresses, shopping, and Joan Collins. And we suspect she's really quite funny when she's not busy cultivating this strange and ultimately self-defeating image that she's all polish and no personality. It's almost as if she believes that the seat she occupies atop of the hierarchy of British celebrity is a *real* throne.

So it pains us to say this, but, Posh, look at the facts: Books can be ghostwritten, songs can be produced and Pro Tooled into generic dreck, and you can slap your name on clothes someone else made; it's easy enough to commission a crown (sensing a theme here?) to be sewn on the pockets of some Rock & Republic jeans and pretend it means they're touched by you. But none of that's quite real, is it? We think it's high time you found something that requires you to let down your guard, put yourself out there in an inarguably real and spontaneous way, and live or die by something that's unquestionably yours.

Until then, all this pomp and circumstance and froofery, however engaging or amusing, ends up seeming sort of delusional in the cold, hard light of day. And you can't escape that just by wearing huge sunglasses.

Debbie Harry

Former lead singer of Blondie

Okay, don't get your panties in a bunch. We KNOW Debbie Harry is cool. Everyone knows Debbie Harry is cool. In a way, that's part of the problem. Cher can get away with wearing a full-scale model of the *Titanic* in her hair because she's CHER. Beloved by the kitschy and the gay, she's never pretended not to be over the top. Whereas Debbie Harry—punk goddess—belongs to the world of the blasé, the louche, the slouchy. Her coolness is supposed to be effortless. Her chic just *happens*.

Except when it doesn't.

Should the woman who declared "Call Me" be wearing a turban of Elmo? Or a Bedazzled T-shirt? She looks like she's Mitzi, the Wacky, Nosy Neighbor on a generic, low-budget CW sitcom starring Haylie Duff as a sassy young advertising executive with an apartment and wardrobe far beyond what she could realistically afford and coworkers far more attractive than anyone who isn't an actor would be. Mitzi will occasionally pop into Haylie's apartment to dispense witticisms and touching advice about life, like Mona Robinson crossed with Mrs. Garrett. This role should be played by Edie McClurg, not Deborah freaking Harry, and we object.

Speaking of being miscast, here's Ms. Harry in the role usually played by Sasquatch. If it's so cold, take the show inside! Besides, aren't you punk? Freeze your ass off! It's rock'n'roll!

And here she is, playing *Sex and the City's* Carrie Bradshaw, complete with aggressive tulle and paper flowers as pins.

We couldn't help but wonder: What's going on around her waist? Is that some kind of postmodern cummerbund, or was she mauled by a beaver on the way to the orange-and-pink carpet?

Either way, she should consider professional help in the form of medical attention and/or a stylist without a Patricia Field fixation. Because Debbie Harry—she of the former shocking platinum hair, a woman who actually pulled off a prehistoric rap including the lines, "'cause the man from Mars stopped eating cars, and eating bars, and now he only eats guitars." (Why, we ask you, would something with a taste for cars start eating *guitars*? Oh, we think we just answered our own question. It likes METAL. She IS a genius!)—should not be impersonating anyone. Not a character actress, not a yeti, and, most of all, not Sarah Jessica Parker.

Juliette Lewis

Actress, Scientologist, "singer"

Remember when Juliette Lewis dated Brad Pitt? We totally forgot about that too! All the Jennifer Aniston/Angelina Jolie stuff has kind of obliterated the fact that Brad was once the greasy-haired paramour of wacky Juliette. Although, now that we think about it, this does kind of cement his later attraction to a woman who, by her own admission, used to wear a vial of a dude's blood around her neck. He likes them a little off-kilter. Now that we've figured this out, we're surprised things lasted with Rachel as long as they did.

Juliette always was a bit kooky—she DID wear cornrows to the Oscars—but once she started her band, Juliette and the Licks, it was as if she'd suffered a head injury and woke up in a full-on Cher fugue state. Although we've never seen her perform, our suspicion, after looking at her stage wear, is that her music sounds like the love child of Poison and the *Wonder Woman* theme song.

We've seen this outfit before. Was it at Drag Nite at Bay Cities Bowl? No, the wig is too cheap for that. Was it at that Gwen Stefani Impersonators Convention we attended last month? No, Gwen would never coordinate knee pads with cheesy pleather boots. Oh, of course! It was the *Rollerball* Tribute Party to Benefit Chris Klein, where Juliette and the Licks performed a number specifically written for the occasion, called "Katie's a Scientologist, You're Just Out of Work." His career *has* really gone downhill, by the way. Please give generously.

Lest you think that Ms. Lewis is simply an entertainer with a wacky love for spandex, we regret to inform you that her red-carpet wear is often just as unfortunate.

Yes, that IS a pair of suspendered pants layered over a plunge-neck, ruffled, sideless bodysuit. She looks like a Las Vegas showgirl as costumed by Annie Hall, and the black ruffles have the unfortunate effect of making her look as though she's got some serious chest hair. Not to mention the fact that wearing a bodysuit under any kind of overalls is absolutely the worst idea ever, unless you enjoy spending the vast majority of your evening in the bathroom, undoing and redoing the many snaps and buttons you've attached to yourself. By the end of the night Juliette's going to be the pee-stained girl with chest hair.

What is she now? A Girl Scout? A Mousketeer? A car hop? A Britney Spears impersonator? A docent at the Museum of Kneesocks? A Nair spokesperson? Someone petrified of deep vein thrombosis? The keynote speaker at a hot-pants convention? What? What is she supposed to be here? WE JUST WANT TO KNOW.

Bai Ling

Sky Captain and the Longest, Worst Movie Title Ever

Hang on to your pants, because we are about to rock your world: Bai Ling isn't *entirely* the anonymous wackjob we've always taken her to be.

Sure, she hasn't headlined any major English-language movies that anyone has cared about, but she did score small guest parts in *Lost* and *Entourage*, plus supporting roles in movies, including *Sky Captain and the World of Tomorrow* and *Anna and the King*. Of course, none of those are as awesome as her trumpeting her role in *Revenge of the Sith* by appearing on a highly publicized "Women of Star Wars"–themed cover of *Playboy*, only to find out too late that she'd been completely hacked out of the film. To us, that will always be her career highlight.

Still, she hasn't necessarily earned the right to strut around in a negligee and expect people to wave it off.

This lacy black number is a very sexy nightgown that would make a fetching addition to any girl's honeymoon trousseau. For a day on the town, though, not even Cher would wear this, unless it were paired with a crown of feathers. Which we'd be fine with, because she's Cher. Bai Ling, however, is just trying to get people to think she's a twenty-one-year old ingenue rather than a thirty-seven-year old whose résumé nobody can remember.

However, Bai Ling must be *incredibly* entertaining to hang out with sometimes.

Just look at how happy she is: Stationed in front of her very favorite thing, a camera lens, she's jovially trying to dance on a table without actually having a table to dance upon, and she's waving her hands in the air like she just don't care. While wearing a polka-dot bra and a skirt sewn to a matching cummerbund. You know, as one does.

However, what she wore on VH1's *But Can They Sing?* takes the cake.

Bai Ling tried to beat the master at her own game and failed: In a Marilyn wig and a bejeweled bikini, Bai Ling performed "I Touch Myself" for a studio crowd of about thirty and a viewing audience of approximately five, none of whom were convinced of her mad skills and *all* of whom came away terrified. It proves once and for all that being Cher is about more than just glitter and nice abs.

Stephanie Seymour

Model, semiprofessional seminudist

Model Stephanie Seymour is a hot dish, of this there is no doubt. Most of the time, when she goes out, she looks fine.

Sure, this dress appears to have giant dots attached to it, but in a world where Madonna thinks a crown of thorns really brings out her eyes, Stephanie's in pretty good shape.

Until Oscar time rolls around. Stephanie Seymour is completely, totally, utterly and absolutely incapable of dressing herself for a formal event. You think we're exaggerating? Check out the photos to the right.

There's something to be said for cultivating a sense of mystery; sadly, all she's cultivating is clientele for her obviously excellent waxer. She should just give her a hefty tip instead.

AND THE BROKEN HEADDRESS GOES TO . . .

So much nuttery, yet room for only one winner: **JULIETTE LEWIS**. We had a lively debate about which nominee had the best blend of unexplained and unjustified fashion insanity, plus that special "Who the heck are you?" factor. So that our blood, sweat, and tears weren't in vain, here's a peek at the deliberations.

INT - NIGHT - GFY HEADQUARTERS

Sitting in an armchair in sweatpants, JESSICA wipes Twinkie crust from the corners of her mouth and looks around for her ice-cream spoon. A caftan-clad HEATHER sits across from her on the couch, trying to extract her head from a bag of Kettle Chips without spilling anything.

Jessica: This is a very tough call.

Heather: I think I would say . . . Juliette Lewis or Bai Ling.

Jessica: I agree.

Heather: Oh, shoot, but then there's Stephanie Seymour. She kind of has a lot of wackiness going on right now, and she hasn't really done anything since she was a Victoria's Secret model. *And* she seems to have lost her marbles. Seriously, most of the pictures of her at other events are totally okay and normal and regular. And yet, for the Oscars? LINGERIE.

Jessica: The Oscars are a heady, sexy time.

Heather: But she might have earned a mental health pass for being married to Axl Rose. That must have been difficult.

Jessica: It *is* hard to hold a candle in the cold November rain.

Heather: Exactly.

Jessica: I'm torn, seriously, on the other two. I feel like I would be likely to say, "Oh, of COURSE Bai Ling is wearing that—she has seventeen personalities," which inches back toward Cher territory, and also likely to say, "Whoa, Juliette Lewis, WTF?"

Heather: Juliette did show up in cornrows at the Oscars that time. Maybe we should have seen this coming.

Jessica: Plenty of people with cornrows don't sweat through strange jumpsuits.

Heather: That's true. And I'm far less amused by her than I am by Bai Ling. I find Bai kind of enchanting, whereas Juliette Lewis and her crotch sweat stains just kind of freak me out and I want to make her stop.

Jessica: If we achieve only that, then we've lived a full life.

Heather: I think we have a winner.

The Fug of All Fugs

Fugliest

Fughound

That Ever Fugged

And here we are at last, faithful fug followers. We have reached the zenith of our journey, the apex of our awards, the cherry on the Fug sundae. It is time, at last, to recognize the one person who most completely represents everything for which the Fug Awards so bravely, and bitchily, stand: a total, complete, utter, far-reaching and spectacular heinousness that goes above and beyond just wearing the occasional mesh bodysuit or cheap wig.

 he winner of this award will be more than just publicly shamed by our recognition. In addition to her cracked-mirror-themed statuette, she will immediately be escorted from the building and into a safe house, where she will undergo serious behavior modification therapy—up to and including electroshock treatment—in the hopes that she will never, ever repeat the sins of her past.

Oksana Baiul

Olympic ice-skater, judge on *Master of Champions*, and . . . we're honestly not sure

The world is a place of many mysteries. Do UFOs exist? Are any of the JFK conspiracy theories true? Is the moon made of green cheese, and, if so, how is that different from blue cheese? Who, exactly, decided that David Blaine was a good idea? And what *is* the airspeed velocity of an unladen swallow? These are the questions over which our minds puzzle at night, despite knowing that it's futile and that we're probably never going to get the answers we seek.

In 2006 we added one more perplexing mystery to the list: Oksana Baiul's presence on Hollywood's red carpets, and the bewildering, often frightening wardrobe decisions she makes for those appearances.

For the uninitiated, Oksana has a Lifetime Television for Women Story of Tragedy (for real—there was a movie) that involves being abandoned by her father at age two, orphaned by the deaths of everyone else by age thirteen, and overcoming an injury to win an Olympic gold medal in a manner of which Nancy Kerrigan is probably extremely envious. Oksana has also successfully battled substance abuse demons, which makes her omnipresence in the Hollywood scene even *less* comprehensible—why would you want to hang out with all those boozy, stoned asshats at all, much less if you're on the wagon?—and she has been a guest judge on a very strange and confusing special on ABC called *Master of Champions*, in which a bunch of odd people with skills like balancing dogs on their noses while juggling fire and baking a perfect pear tart compete to be crowned Most Talented at Something Totally Worthless.

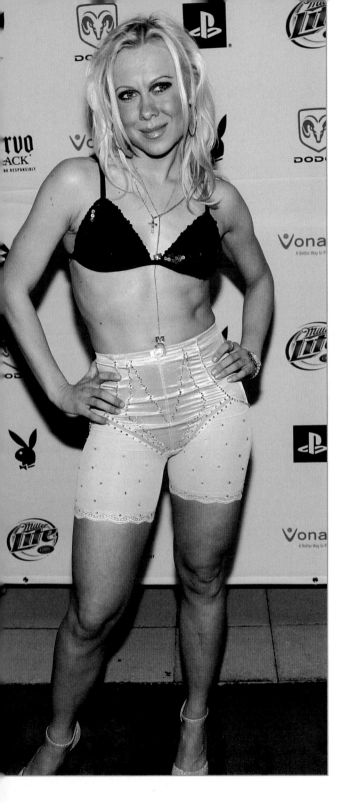

All of which has, for one reason or another, apparently led Oksana straight down Nutbar Street to a place where she wears bras to parties.

Honestly, how are we supposed to react to this? Plenty of *other* tragic people whom Lifetime has immortalized haven't met with this fate. Should we be grateful that she's trying to make it hip to dress like a washed-up lady wrestler angling for a comeback? Or can we go ahead and drop our jaws at her control-top satin bike shorts and then cradle our heads in our hands as we weep for the future? Even Oksana herself seems totally confused as to how this comes across. With those rosy cheeks, the coy head tilt, and the angelic half-smile, we're quite sure she's under the impression that she looks sweetly pretty. She's like the girl next door all grown up into a young lady who can't contain her sexuality, yet doesn't understand why you don't want her babysitting your eight-year-old son anymore.

Although, with skills like these, she might consider dumping babysitting for the world's oldest profession. (Also, check out that eye shadow! You could plug your curling iron into those electric sockets.)

Here, we're a little afraid of the raging man-pelvis Oksana has given herself (seriously, how many crunches *was* that?) And yes, we know, that's more about her workout habits than the clothes; also, she's not helped by the fact that we managed to find a photo of her standing next to fellow nominee Blu Cantrell on the one day of the year when Blu is dressed like a regular human being. But the way we see it, there's a reason Pink wised up and stopped flaunting her overexercised, bizarrely masculine abs. Oksana would do well to heed that example and stop altering her T-shirts—yes, honey, we see that little knot up there around your rib cage—to show off a stomach the likes of which is rarely seen outside Abercrombie & Fitch ads where naked men play naked Ultimate Frisbee while naked flexing.

And lest you think we just have something against ice-skaters, we're here to say that we loved *Ice Castles* and would often dream of being tragically blinded by a crash into a bunch of chairs and then still skating the program of a lifetime in front of a bunch of fans (and the boy of our dreams) who were then heartbroken to find out we couldn't see, yet totally impressed by our moxie. We've had multiple viewings of *Ice Princess*, starring Michelle Trachtenberg and Kim Cattrall, even though it's a catastrophic blemish on the film world. We remember fondly the thrilling Battle Royale between Canada's somersaulting Brian Orser and the U.S.'s Brian Boitano and his bajillion triple jumps, we ate up the Tonya Harding debacle, and we will be devastated if anything happens to Dick Button to prevent him from voicing his sometimes disapproving yet always entertaining commentary during competitions. So it would be accurate to say that the thing we actually *like* about Oksana is that she used to strap on the skates and whip out some toe loops. And if outfits like this one were intended simply to bring a little bit of *Stars on Ice* to the red carpet, well, we can at least say with honesty that we admire her commitment to the sport. But that doesn't mean we have to like the ensemble. And it certainly doesn't indicate any understanding of the logic behind pairing wee dresses with fur vests, leg warmers, and pumps, in large part because we can't fathom what climate this outfit is supposed to match.

But that's Oksana in a nutshell: Unfathomable. Bonkers. And *always* around, like a little sister who won't give you any private time even though you've specifically told her you are going through something very important that has to do with Duran Duran and need to use the phone for three hours BY YOURSELF.

Week after week Oksana tops her own sartorial illogic. She looks nuts almost all the time, and in new and special ways that usually eclipse all her more famous company at these events—events we're not sure how she got into, but which we are forever grateful she was invited to, enabling this endless supply of fug.

Blu Cantrell

Singer

One-hit wonder chanteuse Blu Cantrell found a fair amount of success with her smash single called "Hit 'Em Up Style (Oops!)," a catchy number entreating any lady whose man has stepped out on her to get back at him by totally jacking with his credit score.

But whereas that song will soon be lost entirely to the mists of time, we suspect that Blu's fashion choices will burn brightly forever as examples of everything that could possibly go wrong with textiles.

For example, what could her beach towel possibly have done to warrant this kind of treatment?

See, towels go around your head or under your bum or, if you are a quarterback, tucked into the waistband of your football pants. They do not act as the left leg of your trousers. You do not match them exactly to your tank top unless you are that unbearably cute girl in yoga class.

Frankly, this ensemble seems potentially dangerous. Couldn't it get caught in her car door? How easy would it be to accidentally flick that thing into a roaring fireplace? On the other hand, this outfit is ideal for events where they've run out of napkins.

That's not a top. That's a pashmina, belted. You can even see the fringe at the bottom. And while we salute Blu's ingenuity as far as recycling an outdated trend, we might have recycled it into something that was not a shirt. Something like an elegant flag for a girls-only treehouse or an inordinately soft tablecloth for a gender-neutral baby shower. Or the fanciest dust rag ever. Because if we begin to wear pashminas as shirts, what's next? Belts as skirts? Doilies as vests?

Oh, wait:

If our eyes do not deceive us, it appears that Blu's nipples are covered solely by (a) the strap of her handbag and (b) her hair. HAIR IS NOT A SHIRT.

And *this* is acceptable in only a few instances: She is a comic book superhero; she is at a comic book convention, *playing* a superhero; or she is on *Heroes*. Even then, it's questionable. What's with the side abs obsession? It is a truly bizarre body part on which to become fixated. Breasts, we can understand. Standard-issue front abs, sure. But side abs? That's just weird.

Lindsay Lohan

The Parent Trap, Mean Girls, Freaky Friday, Bobby

Our love for Lindsay Lohan burns bright and deep and true, despite all the terrible life choices she's made in the past few years. After all, it's not like the girl doesn't have a lot on her plate. She's had to deal with a trashy mother and a criminal for a father. She's been rumored to be a cutter and an alcoholic, and accused of using any number of drugs. She's gone to rehab at least three times, and while claiming sobriety she was supposedly caught on video with a friend shoving cocaine up their noses. She's been to the hospital countless times for everything from "exhaustion" to allegedly slicing her leg open on a teacup at Bryan Adams's house (which we desperately hope is true, as it's the most brilliant line we've ever heard). She's had a series of bad breakups and seems to have questionable taste in boyfriends. She cannot spell and doesn't know the exact meaning of the word "adequate," much less which vowels it contains. She was reprimanded publicly for having a poor work ethic. She has crashed her car more than once. She allegedly wrote unflattering comments about Scarlett Johansson on the wall of a public bathroom, and she called Paris Hilton, on video, some words we choose not to reprint here. The veracity of her breasts has been debated to death in the media, as has her up-and-down weight. She was one of the first starlets to surprise the paparazzi during the Great Vagina Flashery of 2006. And, in perhaps the most humiliating entry on her list of shame, she allegedly feuded with Hilary Duff over Fug Award Nominee Aaron Carter, of all people.

And yet, there is something about La Lohan that compels us to root for her. Maybe it's because she seems legitimately talented, or maybe we just really loved *The Parent Trap*, but any way you slice it, we want her to pull it together and stop going out in stuff like this.

Yes, it's a pantaloon shorts jumpsuit. She's wearing it on purpose, and in public. It is not a costume. What it *might* be is a sign of End Times.

Let's turn our attention away from On-the-Streets Lindsay to Red-Carpet Lindsay:

Cuffed denim shorts haven't been appropriate formal wear *ever*, even if you are named Baby and someone is trying to put you in a corner.

Neither are gauchos paired with a chauffeur's cap. This look evokes some long-lost eighties movie about a girl who runs away from a small town to Manhattan, where she plans to make it as a dancer. To afford the rent on her "squalid" (read: adorable and huge) apartment, which is conveniently next door to an incredibly cute, single straight boy, she takes a night gig driving a town car. While behind the wheel, she meets a powerful but sleazy man who promises her the primo position in his dance troupe if she'll just give it up. Of course, because this film is rated PG, Lindsay ends up with the neighbor, the sleazebucket gets thrown into prison for tax evasion, and his sharp-eyed, sassy mother takes over the troupe. She gives Lindsay the lead position on the strength of her skills on the dance floor, not in the sack, and in the final scene, Lindsay throws her jaunty cap gleefully into the sky, à la Mary Tyler Moore. This might be the charming sort of movie that you watch on the USA network on a rainy Sunday while eating tacos and recovering from a hangover. But it should not be your fashion inspiration.

Come on, Lindsay, you *know* we can see your boobs. You *must* be doing this for attention, although possibly you just wanted to show us all how pert your breasts are. And we aren't saying they're not nice; we simply think you need to keep that between yourself, your boy toy of the moment, and possibly your doctor. Nipples rarely enhance a look, unless the look you are going for is less "working actress" and more "working girl."

We know you've got that adorable little redhead from *The Parent Trap* somewhere deep down inside you, doing secret handshakes and trimming your bangs. Please, let that girl out again.

Sienna Miller

Factory Girl, Layer Cake

Any discussion of the fugliest people of our era would be incomplete without Sienna, the inexplicably lauded Boho Queen who repeatedly drives us to drink—and, the next morning, to the drugstore for some aspirin—with her crazy cocktail of clothes. She scrambles our brains day in and day out, and, frankly, we need her to give it a rest. It's hard enough for us to remember what day of the week it is; we don't need to expend any more mental energy trying to understand why she's wearing granny panties outside her stockings.

We don't care if those are an homage to Edie Sedgwick or to the softer side of Sears: Granny panties are never an appropriate tribute to ANYTHING. Not to panties, and certainly not to grannies. Frankly, we can't believe Anna Wintour is able to smile so politely in the presence of this public affront to groins, although perhaps she's just busy rooting around in her pockets for some blotting papers to proffer. Or paging her bodyguard.

Wearing a scarf over hot pants while barefoot might make sense if Sienna were, say, walking back to her car from the beach, or starring in a very socially important HBO miniseries about the near-fatal dangers of foot fungi. But, personally, on those heady days when *we* want to troll filthy back alleys in London, we prefer wearing things like shoes. And pants. And SHOES. This is giving people very bad ideas, Sienna. Maybe you *should* make that HBO miniseries. Think of the children.

And this yucky, figure-ruining strapless jumpsuit is . . . well . . . it's . . . *a strapless jumpsuit*.

Congratulations, Sienna: You have reduced us to ellipses. You broke the Fug Girls.

Britney Spears

Singer, failed actress, failed reality star

Once upon a time, we didn't have to defend our Britney love. She was cute, she bathed, she sang catchy songs, you could grate ginger root with her abs, and you could even get respectable people like Natalie Portman to stand near her and smile.

Drink it in, folks, because this won't happen again without a brilliant optical illusion involving a series of mirrors.

It would have been difficult back in the ". . . Baby One More Time" years to believe Britney's downward spiral (the quickie Vegas marriage, the Federline years, that whole head-shaving drama) would be *so* epic, yet those innocent days—when we still believed that you could take the girl out of the trailer *and* take the trailer out of the girl—are a long way behind us now. And although we already knew that Britney loves nothing more than frolicking barefoot in gas station bathrooms on her days off, now that she's free from her crew of handlers, she can't even clean up for the media. The girl is ten miles of rough road, and all the city workers are on strike.

Tragically, we're pretty sure Britney slipped this green *FernGully on Ice* costume on and said to herself, "Y'all, I look tastier than a Thin Mint." When, in fact, she looks like a fallen Girl Scout selling a whole *different* kind of cookie. And, of course, leave it to Britney to accessorize a high-profile post-divorce outing with (a) Paris Hilton, arguably the only person America hated at the time as much as K-Fed, and (b) *one* leg of a pair of fishnet stockings, with Paris sporting the other. Please, don't ask yourself how these debauched twerps pulled that off, because down that rabbit hole lies insomnia and a smoking habit.

"I'm a washed-up showgirl at the Las Vegas Shoehorn Jack Casino Royale and Comfort Inn—would you like the $4.99 prime rib special while I sing?"

Ignoring the disastrous cleavage, it's downright tricky to tell whether this is Britney or a first-year NFL linebacker forced to go to the ESPY Awards in drag as part of his hazing.

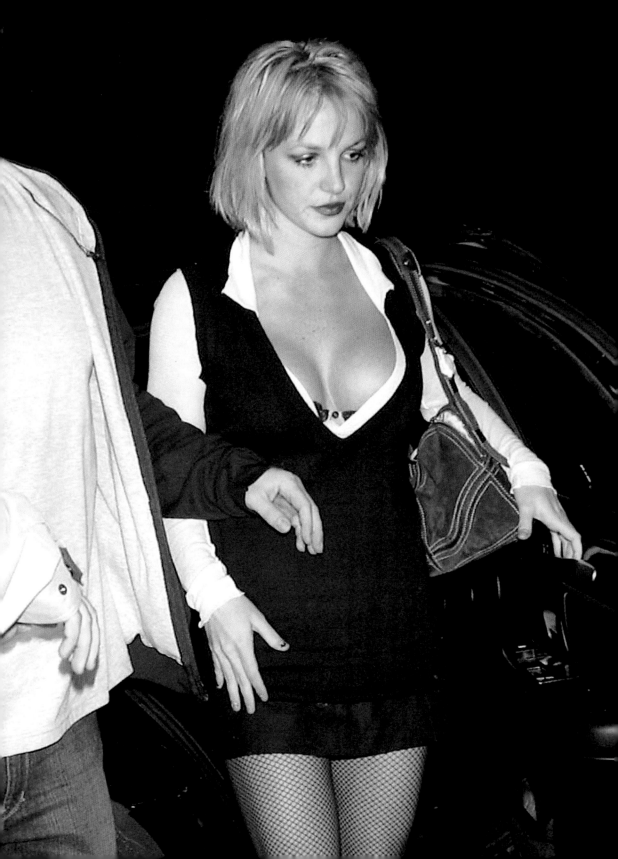

We can only assume this was intended as an homage to the timeworn "sexy secretary" costume, beloved by lazy girls who don't have a clever Halloween idea but still desperately want to bar crawl on the one night of the year when it's acceptable to expose your bra. Unfortunately, Brit's aim was off, and she landed somewhere closer to a *Halloween* victim being helped out of a ditch after a dying Michael Myers gave her a haircut. It's yet another excellent example of the tragic, unshowered aura that's oozed from poor Britney since things went so massively pear-shaped.

AND THE CRACKED
MIRROR GOES TO . . .

Admit it, you thought it was going to be Britney, didn't you? A reasonable assumption, considering . . . well, just *look* at the girl. She *crazy*. And at one time, bald (who will ever forget the Clippers Heard Round the World?). Yet our residual affection for Little Miss Hit Me Baby is so strong that we still truly believe, deep down—way, way deep down, way far in the deepest, coldest, most rarely accessed recesses of our soul—that she is going to clean it up and give us the comeback we

all thought would happen the minute she served Kevin Federline with divorce papers. We truly hope that by the time this book is in your hot little hands, she will have placed the days of hose-swapping with Paris Hilton and spending more time in bars than reading bedtime stories to her children *far* behind her. And because we still believe this is possible, we have decided not to jinx things by anointing her the Fugliest of the Fugly. Look, if nutty R. Kelly can believe he can fly and believe he can touch the sky, we can hold tight to this.

Instead, we're going to hand the title over to the skater and the (other) singer, **OKSANA BAIUL** and **BLU CANTRELL**. Judging from the amount of time these two spend draped over each other at events, we assume they are friends. And from the looks of things, each is guilty of aiding and abetting the other's bad fashion choices. Therefore, we award this to them as a couple, in the hopes that they can kick the habit together and help each other stick to the straight and narrow from here on out—you know, like how married people quit smoking together so that the one who's still lighting up doesn't drive the other to homicide. Oksana can confiscate Blu's doily tops, and Blu can yell at Oksana if she tries to leave the house wearing only a girdle. They can go on shopping trips together, and one can force the other to stay strong if she decides that she really needs leg warmers that double as a tube top. Maybe they can even take a field trip to a store that sells items made from natural fibers. This will only strengthen their bond, we feel.

Therefore, in addition to performing a public service by getting these two off the street, we are pleased that we're also able to fertilize the bloom of their friendship. Friends are good. Friends don't let friends wear sheets for shirts. The more friends all these girls get, the less work we'll have to do. Which is a bonus. We're very lazy. And at this point in our festivities, very tired.

The Afterparties

Because

All Good (and Bad)

Awards Shows

Must Come to a Dizzy End

In our fantasy of having our own televised Fug Awards show, this is the point in the festivities where our host, Courtney Love, would duck out from behind a curtain and scream that it's time for everyone to get the [BLEEP] out of here and go find a freshly stocked open bar. That is, if the orchestra isn't still busy frantically playing off the final honoree while he or she tries to choke out the names of all ten agents and managers who are responsible for the win.

hat's where the afterparties come in, bless them; the glorious evening can stretch on until the wee hours. First, of course, there would be the City Comptroller's Gala for all the winners, where we fully assume a Bellini-fueled Kenny Rogers would climb up on the buffet to lead a chorus of "Lady" before falling into the chocolate fountain. And gossip columnists would be abuzz with a K-Fed sighting:

WE HEAR . . . that Kevin Federline had no idea what he was doing tonight. Our spies saw the reedy would-be rapper storm up to the bouncers at Hamburger Hamlet and demand to be allowed to bring in twenty friends because he "ain't never not been rollin' with my posse at the VMAs." When the bouncers tried to explain to Federline that the VMAs are a completely different event, K-Fed got huffy and spat, "Vodka's all the same, bitches!" before shoving his way inside, past the very confused Hamlet staffers . . .

Over at the *Nun's Life* soiree at the Hustler store on Sunset Boulevard, Sienna Miller would be caught sneaking out with nine gift bags, fully intending to turn them into an outfit; meanwhile, Errstyle champion Sharon Stone would set tongues wagging by cornering Carefrontations nominee Rupert Grint and asking to see his magic wand. Later it would turn out not to have been a euphemism at all, but, in fact, a legitimate query sparked by her confusion over thinking the Harry Potter books are nonfiction. Grint would then scurry over to the shindig at a Baja Fresh in Beverly Hills cohosted by WHEE! Entertainment Television and the Spam Merchandise Catalog, where he'd engage in some competitive eating with the sticky, drenched Davis brothers, who are too idiotic to realize their win was actually an insult. Then, during Grace Jones and Dolly Parton's performance of a hotly anticipated Nirvana adaptation, "Smells Like Fug Spirit," Lindsay Lohan would busily scrawl insults about other starlets on the bathroom walls before dumping her drink on Ashlee Simpson's head. Fortunately for the latter, her habitually gnarly, stringy hair would prevent anyone from noticing things had gone awry. Meanwhile, WHEE! Online's Ned Sofanegra would be scribbling frantically in his notebook.

Jamie Kennedy looked wicked in a trucker hat, which prompted me to ask this dirty trucker-with-an-f where he'd rather have sex: in a pair of badly hemmed pants, or in the flatbed of my uncle's Ford F-150? Not that I'm trunk-junk-hawkin', mind you; just tawkin' trash, as we Naughtywood types lurve to do!

Of course, the big party of the night would be *Vogue*'s epic bash, but none of us would actually be invited because we're too awful. So instead, after breaking up yet another fistfight between Dr. Noooooo! loser Faye Dunaway and event accountant Bea Arthur—sheesh, you'd think they'd give it a rest for once—we'd retreat to an In-N-Out Burger and relive the evening before retiring to GFY HQ for our nightly foot rubs from Intern George.

What can we say? We dream big. And while we'd like to pretend that's the overarching, profound moral of this tome, really, the biggest message we're trying to send is, "Don't try any of this at home."

Except for the Grace Jones look—we're dying for someone else to try to make *that* work.

257

$\mathscr{A}cknowledgments$

Everything we are, we owe to our amazing, supportive, and devastatingly attractive families: Susan and Jim Morgan; Elizabeth Morgan; Kevin Mock; Alan and Kathie Cocks; Alison, Mike, Leah, Madeleine, and Lauren Hamilton; Colin O'Sullivan and Dr. Julie O'Sullivan; and those who are no longer with us but who we hope are leafing through a copy of this book up inside the pearly gates. Eternal love and gratitude to: Carrie Weiner, Lauren Shotwell, and Jennifer Pray (our Bitch Posse), Grant Rickard, Jennifer (Conway) Woldman, Eliza Hindmarch, Michael Williams, Kevin and Mary Beth Hughes, Dan Cichalski and Casey Barber, Aletha Wild, Dave Grubstick, Francis Gasparini, Blake Levin, R.J. Cutler, Ken Mok, Steve Sicherman, and Chuck Cole.

We'd like to clutch the following wonders of the world to our grateful bosoms: Scott Hoffman, our brilliant agent, for having the foresight to introduce himself to us over cocktails; our funny, yet mysterious editor Jeremie Ruby-Strauss, our delightful savior Ursula Cary, the ridiculously talented Jane Archer, and the entire team at Simon Spotlight Entertainment; Kim Fox, our rock star behind the lens; the makers and distributors of Diet Coke; Ed Labowitz, the most gifted and wise lawyer/folk musician in the world; Nicole DiBlasi, Sarah Indovina, and Jennifer Bye from Getty Images, as well as their researchers; Elisa Miller; Joan Collins, for the inspiration; Henry Copeland, Nicole Bogas, and the BlogAds team; the always delightful Brooks Barnes; Amina Akhtar and Aileen Gallagher, forever our queens, and Ben Williams, our viceroy; Blaine Zuckerman and Ashley Baker, for being appropriately glamourous; Vegas showman Danny Gans (he knows why); Jill Stempel at WENN; the Hollywood Foreign Press Association; Michael Bernstein and Rachel Wareham, who keep us in good with the IRS; Craig Bland, Tyler Goldman, and all the staffers sitting at IKEA desks over at Buzznet; the various sports teams of UCLA and Notre Dame; Jason Toney, for letting us pick his seriously fancy brain; the inventor of the sandwich; Jarett Wieselman and Debbie Emery; Omar Gallaga; David Cole, Tara Ariano, and Sarah Bunting, for propping us up when *ER* and *Dawson's Creek* broke us; Mark Lisanti, for calling us the Gorgeous Ladies of Fug without asking to see any proof; the entire cast and crew of *Beverly Hills, 90210*, whose work we admired in its entirety while producing this tome; Liz Sterbenz, for giving us Ed; Antonia Mattia, for bringing us to Melissa Rivers; Greg Proops, for letting us bask in the glow of his wit; and, finally, Joan and Melissa Rivers themselves, for being supportive and dishy and divine—and, in many ways, for being the original Fug Girls. You both deserve the best.

GIRL, PLEASE

THE SAG AWARD

PAMELA ANDERSON, P. 33 Andrew H. Walker/Getty Images

DREW BARRYMORE, P. 34 C HFPAR/Golden Globe R Awards/All Rights Reserved

KIRSTEN DUNST, P. 36 Peter Kramer/Getty Images

KIRSTEN DUNST, P. 37 Dave Hogan/Getty Images

MAGGIE GYLLENHAAL, P. 38 Donald Weber/Getty Images

MAGGIE GYLLENHAAL, P. 39 Donald Weber/Getty Images

MAGGIE GYLLENHAAL, P. 39 Carlo Allegri/Getty Images

SCARLETT JOHANSSON, P. 40 Steve Finn/Getty Images

SCARLETT JOHANSSON, P. 41 Kevin Winter/Getty Images

KIRSTEN DUNST, P. 42 Dave Hogan/Getty Images

THE CAREFRONTATIONS: FEMALES

PAULA ABDUL, P. 46 Frank Micelotta/Getty Images

PAULA ABDUL, P. 47 Michael Buckner/Getty Images

PAULA ABDUL, P. 48 Matthew Simmons/Getty Images

JENNIFER ANISTON, P. 49 Patrick Riviere/Getty Images

JENNIFER ANISTON, P. 49 Kevin Winter/Getty Images

JENNIFER ANISTON, P. 50 Stephen Shugerman/Getty Images

JENNIFER ANISTON, P. 50 Evan Agostini/Getty Images

KRISTEN BELL, P. 51 Kevin Winter/Getty Images

KRISTEN BELL, P. 52 Bryan Bedder/Getty Images

KRISTEN BELL, P. 52 Peter Kramer/Getty Images

EMMY ROSSUM, P. 53 Bryan Bedder/Getty Images

EMMY ROSSUM, P. 54 Evan Agostini/Getty Images

EMMY ROSSUM, P. 54 Mark Davis/Getty Images

AISHA TYLER, P. 55 Frazer Harrison/Getty Images

AISHA TYLER, P. 56 Marsaili McGrath/Getty Images

AISHA TYLER, P. 57 Marsaili McGrath/Getty Images

THE CAREFRONTATIONS: MALES

CLAY AIKEN, P. 59 Kevin Winter/Getty Images

CLAY AIKEN, P. 60 John M. Heller/Getty Images

CLAY AIKEN, P. 60 Vince Bucci/Getty Images

CLAY AIKEN, P. 61 Scott Gries/Getty Images

MARC ANTHONY, P. 62 Fernando Leon/Getty Images

MARC ANTHONY, P. 63 Evan Agostini/Getty Images

RUPERT GRINT, P. 64 Peter Kramer/Getty Images

RUPERT GRINT, P. 65 Claire Greenway/Getty Images

RUPERT GRINT, P. 65 Dave Hogan/Getty Images

JAMIE KENNEDY, P. 66 Kevin Winter/Getty Images

JAMIE KENNEDY, P. 66 Paul Hawthorne/Getty Images

JAMIE KENNEDY, P. 67 Kevin Winter/Getty Images

JAMIE KENNEDY, P. 67 Kevin Winter/Getty Images

JEREMY PIVEN, P. 68 Kevin Winter/Getty Images

JEREMY PIVEN, P. 68 Evan Agostini/Getty Images

JEREMY PIVEN, P. 69 Frazer Harrison/Getty Images

PUT IT AWAY

PAMELA ANDERSON, P. 73 David Livingston/Getty Images

KEVIN FEDERLINE, P. 75 Kevin Winter/Getty Images

KEVIN FEDERLINE, P. 76 Ethan Miller/Getty Images

KEVIN FEDERLINE, P. 77 Mark Davis/Getty Images

PARIS HILTON, P. 79 Ralph Notaro/Getty Images

PARIS HILTON, P. 79 David Livingston/Getty Images

PARIS HILTON, P. 80 Frazer Harrison/Getty Images

BAI LING, P. 81 David Livingston/Getty Images

BAI LING, P. 82 Peter Kramer/Getty Images

BAI LING, P. 82 Michael Buckner/Getty Images

Bai Ling, p. 83 Z. Tomaszewski/WENN

Tara Reid, p. 84 Dave Hogan/Getty Images

Tara Reid, p. 85 Donald Miralle/Getty Images

Tara Reid, p. 85 Gustavo Caballero/Getty Images

Tara Reid, p. 86 Vince Bucci/Getty Images

THE PELDON PRIZE

Aaron & Nick Carter, p. 92 Michael Buckner/Getty Images

Aaron & Nick Carter, p. 92 Chad Buchanan/Getty Images

Brandon Davis, p. 93 Fernando Leon/Getty Images

Brandon Davis, p. 94 Kevin Winter/Getty Images

Jason Davis, p. 95 Frazer Harrison/Getty Images

Brandon & Jason Davis, p. 96 Giulio Marcocchi/Getty Images

Mary-Kate & Ashley Olsen, p. 97 Ian Wingfield/Getty Images

Mary-Kate & Ashley Olsen, p. 97 Frank Micelotta/Getty Images

Mary-Kate & Ashley Olsen, p. 98 Pascal Le Segretain/Getty Images

Mary-Kate Olsen, p. 99 Stephen Shugerman/Getty Images

Paris & Nicky Hilton, p. 101 Frederick M. Brown/Getty Images

Paris & Nicky Hilton, p. 102 Scott Wintrow/Getty Images

Paris & Nicky Hilton, p. 103 Stephen Shugerman/Getty Images

Ashlee & Jessica Simpson, p. 104 Amanda Edwards/Getty Images

Ashlee & Jessica Simpson, p. 105 Dave Hogan/Getty Images

Ashlee & Jessica Simpson, p. 105 Dave M. Benett/Getty Images

Jessica Simpson, p. 107 Michael Buckner/Getty Images

Brandon Davis, p. 108 Rob Loud/Getty Images

THE ERRSTYLE

Tyra Banks, p. 111 Vince Bucci/Getty Images

Tyra Banks, p. 112 Frederick M. Brown/Getty Images

Tyra Banks, p. 113 Matthew Simmons/Getty Images

Tyra Banks, p. 114 Amanda Edwards/Getty Images

Tom Cruise, p. 115	Dave Hogan/Getty Images
Tom Cruise, p. 116	Chris Jackson/Getty Images
Tom Cruise, p. 116	Evan Agostini/Getty Images
Vincent Gallo, p. 117	Frazer Harrison/Getty Images
Vincent Gallo, p. 118	Evan Agostini/Getty Images
Vincent Gallo, p. 118	Evan Agostini/Getty Images
Kelly Osbourne, p. 119	Getty Images
Kelly Osbourne, p. 120	Mark Mainz/Getty Images
Kelly Osbourne, p. 120	Vince Bucci/Getty Images
Kelly Osbourne, p. 121	Dave Hogan/Getty Images
Sharon Stone, p. 122	Sean Gallup/Getty Images
Sharon Stone, p. 122	Peter Kramer/Getty Images
Sharon Stone, p. 123	Kevin Winter/Getty Images
Sharon Stone, p. 123	Sean Gallup/Getty Images
Sharon Stone, p. 124	Pascal Le Segretain/Getty Images

THE TANOREXIA AWARD

Katie Couric, p. 127	Lawrence Lucier/Getty Images
Katie Couric, p. 127	Chris Hondros/Getty Images
Katie Couric, p. 128	Zack Seckler/Getty Images
Katie Couric, p. 128	Scott Wintrow/Getty Images
Katie Couric, p. 129	Frederick M. Brown/Getty Images
Lucy Davis, p. 129	Mark Mainz/Getty Images
Lucy Davis, p. 130	Dave Hogan/Getty Images
Lucy Davis, p. 131	Michael Buckner/Getty Images
Lizzie Grubman, p. 132	Getty Images
Lizzie Grubman, p. 133	Scott Wintrow/Getty Images
Lizzie Grubman, p. 134	Paul Hawthorne/Getty Images
Jay Manuel, p. 135	Chad Buchanan/Getty Images
Jay Manuel, p. 136	Brad Barket/Getty Images
Jay Manuel, p. 137	Matthew Simmons/Getty Images
Nancy O'Dell, p. 138	George Pimental/Wire Image

THE DR. NOOOOO!

FAYE DUNAWAY, P. 143	Francois Durand/Getty Images
PRISCILLA PRESLEY, P. 144	Keystone/Hulton Archive/Getty Images
PRISCILLA PRESLEY, P. 145	Chris Jackson/Getty Images
PRISCILLA PRESLEY, P. 146	Brad Barket/Getty Images
PRISCILLA PRESLEY, P. 147	Rod Rolle/Getty Images
TARA REID, P. 148	Matthew Simmons/Getty Images
TARA REID, P. 149	Mark Mainz/Getty Images
TARA REID, P. 150	Vince Bucci/Getty Images
TARA REID, P. 151	Gustavo Caballero/Getty Images
KENNY ROGERS, P. 152	Kevin Winter/Getty Images
KENNY ROGERS, P. 153	Paul Hawthorne/Getty Images
HUNTER TYLO, P. 154	Frederick M. Brown/Getty Images
HUNTER TYLO, P. 155	Getty Images
HUNTER TYLO, P. 156	Peter Kramer/Getty Images
KENNY ROGERS, P. 157	Rusty Russell/Getty Images

THE PITS AND THE PENDULUM

BEYONCÉ, P. 161	Frank Micelotta/Getty Images
BEYONCÉ, P. 162	Carlo Allegri/Getty Images
BEYONCÉ, P. 163	Frank Micelotta/Getty Images
BEYONCÉ, P. 164	Steve Finn/Getty Images
CATE BLANCHET, P. 165	Dave Hogan/Getty Images
CATE BLANCHETT, P. 166	Kevin Winter/Getty Images
CATE BLANCHETT, P. 167	Carlo Allegri/Getty Images
CATE BLANCHETT, P. 168	Stephane L'hostis/Getty Images
FERGIE, P. 169	Mark Mainz/Getty Images
FERGIE, P. 170	Ethan Miller/Getty Images
FERGIE, P. 171	Peter Kramer/Getty Images
FERGIE, P. 172	Frederick M. Brown/Getty Images
TERI HATCHER, P. 173	Stephen Shugerman/Getty Images
TERI HATCHER, P. 174	Sean Gallup/Getty Images
TERI HATCHER, P. 174	Bryan Bedder/Getty Images

Teri Hatcher, p. 175 John M. Heller/Getty Images

Diane Kruger, p. 176 Junko Kimura/Getty Images

Diane Kruger, p. 177 Kevin Winter/Getty Images

Diane Kruger, p. 178 David Westing/Getty Images

Diane Kruger, p. 179 Evan Agostini/Getty Images

Diane Kruger, p. 180 Peter Kramer/Getty Images

Diane Kruger, p. 181 Frazer Harrison/Getty Images

THE CHER

Björk, p. 187 Jo Hale/Getty Images

Björk, p. 188 Junko Kimura/Getty Images

Björk, p. 189 Dave Hogan/Getty Images

Flavor Flav, p. 190 Amanda Edwards/Getty Images

Flavor Flav, p. 191 Ethan Miller/Getty Images

Grace Jones, p. 193 Evan Agostini/Getty Images

Grace Jones, p. 194 Sean Gallup/Getty Images

Grace Jones, p. 195 Evan Agostini/Getty Images

Madonna, p. 196 Junko Kimura/Getty Images

Madonna, p. 197 Gareth Cattermole/Getty Images

Madonna, p. 198 Dave Hogan/Getty Images

Dolly Parton, p. 199 Scott Gries/Getty Images

Dolly Parton, p. 200 Scott Barbour/Getty Images

Dolly Parton, p. 201 Robert Mora/Getty Images

Dolly Parton, p. 203 Kevin Winter/Getty Images

THE CHER-ALIKE

Victoria Beckham, p. 207 Ralph Orlowski/Getty Images

Victoria Beckham, p. 208 Gareth Cattermole/Getty Images

Victoria Beckham, p. 209 David Cannon/Getty Images

Victoria Beckham, p. 210 Salvatore Laporta/Getty Images

Debbie Harry, p. 212 Gareth Cattermole/Getty Images

Debbie Harry, p. 213 Evan Agostini/Getty Images

Debbie Harry, p. 214 Vince Bucci/Getty Images

JULIETTE LEWIS, P. 215 Carlo Allegri/Getty Images

JULIETTE LEWIS, P. 216 Getty Images

JULIETTE LEWIS, P. 217 Mark Mainz/Getty Images

JULIETTE LEWIS, P. 218 Robert Mora/Getty Images

BAI LING, P. 219 Gareth Cattermole/Getty Images

BAI LING, P. 220 Evan Agostini/Getty Images

BAI LING, P. 221 Frank Micelotta/Getty Images

STEPHANIE SEYMOUR, P. 222 Bryan Bedder/Getty Images

STEPHANIE SEYMOUR, P. 223 Mark Mainz/Getty Images

STEPHANIE SEYMOUR, P. 223 Frazer Harrison/Getty Images

JULIETTE LEWIS, P. 225 Getty Images

THE FUG OF ALL FUGS

OKSANA BAIUL, P. 230 Evan Agostini/Getty Images

OKSANA BAIUL, P. 231 Rob Loud/Getty Images

OKSANA BAIUL, P. 232 David Livingston/Getty Images

OKSANA BAIUL, P. 233 Scott Wintrow/Getty Images

BLU CANTRELL, P. 234 Steve Finn/Getty Images

BLU CANTRELL, P. 235 Alexander Sibaja/Getty Images

BLU CANTRELL, P. 236 Michael Buckner/Getty Images

BLU CANTRELL, P. 237 Michael Tullberg/Getty Images

LINDSAY LOHAN, P. 239 Uri Schanker/Getty Images

LINDSAY LOHAN, P. 240 David Livingston/Getty Images

LINDSAY LOHAN, P. 241 Scott Gries/Getty Images

LINDSAY LOHAN, P. 242 Frazer Harrison/Getty Images

SIENNA MILLER, P. 243 Brad Barket/Getty Images

SIENNA MILLER, P. 244 David Westing/Getty Images

SIENNA MILLER, P. 245 Frazer Harrison/Getty Images

BRITNEY SPEARS, P. 246 Matthew Peyton/Getty Images

BRITNEY SPEARS, P. 247 x17Online.com

BRITNEY SPEARS, P. 248 Matthew Simmons/Getty Images

BRITNEY SPEARS, P. 249 Kevin Winter/Getty Images

BRITNEY SPEARS, P. 250 Arnaldo Magnani/Getty Images